The Art of Layering: Making Connections

CO-EDITED BY **MARY CARROLL NELSON**
NANCY DUNAWAY
PREFACE BY **RICHARD NEWMAN**
FOREWORD BY **JOHN BRIGGS**

The Art of Layering: Making Connections

Society of Layerists in Multi-Media
PO Box 66480
Albuquerque, New Mexico 87193

ISBN 0-9628851-1-8

Library of Congress Catalog Number 2004090392

First Edition

Published by Society of Layerists in Multi-Media

Dimensions of all artwork are in inches, height by width.

Table of Contents

Acknowledgments

The Art of Layering: Making Connections has been a collaborative effort. We would like to thank those members who have made the book possible.

Editors:
 Mary Carroll Nelson and Nancy Dunaway

Assistant:
 Joy Barnaby

Planning Committee:
 Marilyn Christenson, Diane Courant, Janaia Donaldson,
 Nancy Dunaway, Leslie Ebert, Ilena Grayson, Ann Hartley,
 Marianna Love, Mary Carroll Nelson, Richard Newman,
 Nancy Egol Nikkal, Delda Skinner and Juliet Wood

Selection Committee:
 Susan H. McGarry, Leader, with Marilyn Christenson,
 Ilena Grayson and Mary Carroll Nelson

Selections Reviewed by:
 Nancy Dunaway, Richard Newman and Delda Skinner

Editorial Committee:
 Diane Courant, Leader, with Leslie Ebert,
 Nancy Egol Nikkal and Jean Nevin

Design Committee:
 Nancy Egol Nikkal, Leader, with Janaia Donaldon
 and Jean Nevin

Liaison, Editorial and Design Committees:
 Nancy Egol Nikkal and Jean Nevin

Designer:
 Fabian West, San Marcos, TX

Print Broker:
 Ink & Images, Inc., Albuquerque, NM

Printer:
 Starline Printing, Albuquerque, NM

Dedication

BY NANCY DUNAWAY

Richard Newman has led the Society of Layerists in Multi Media as its president since 1986. His easy manner and sense of humor often hide the enormous amount of energy and hard work he has invested in this position. His tenure has seen an enhancement of SLMM's high standards, an increased visibility of the society itself and a marked growth in membership. Richard is the embodiment of the premise of layering—sharing himself, his passion for art, his intellectual and spiritual curiosity with each and every member with whom he comes in contact. His own work is a standard to which we all aspire—beautiful in concept and craft, imbued with personal and universal connections, it is a visual meditation.

It is with much love, respect and great appreciation that we dedicate this book, *The Art of Layering: Making Connections* to Richard Newman.

A PERSONAL REFLECTION

BY RICHARD NEWMAN

My introduction to the Society of Layerists in Multi-Media began in the fall of 1983 when I first met Mary Carroll Nelson, the founder, for an interview at my studio in Massachusetts. Our meeting was in preparation for an inaugural exhibition Mary was organizing which carried the same title as her companion monograph, "Layering: An Art of Time and Space." The exhibition was held at The Albuquerque Museum in the summer of 1985. I flew to the opening in New Mexico to meet the other artists who were showing their work under this new designation. Little did I know, then, that my involvement with SLMM would carry on for these many years: first as a signature member and then as its second President from 1986 to 2004.

My willingness to stay connected with SLMM related to my level of comfort with its premise. Not only did I welcome the opportunity to become acquainted with artists eager to share their passion, but I recognized how it could contribute to my own development as an artist. The supportive and noncompetitive outlook of the Society which greeted me in those early days, and continues today, reminds me of the writer Annie Dillard's admonition,

> "The impulse to keep to yourself what you have learned is not only shameful, it is destructive.
> Anything you do not give freely and abundantly becomes lost to you. You open your safe and find ashes."

SLMM is composed of individuals who use the experience of art to cultivate their spiritual awareness; therefore, my interaction with members down through the years has been extremely fulfilling. Whether I am engaging their thoughts or contemplating the artistic products that emerge from each unique perspective, the result is the same. Their company provides a nurturing place where I can become enriched and energized. They reinforce the notion that creative encounters can be dedicated equally to preserving the traces of the journey as well as the final destination. What one ultimately discovers as a mature artist is that nuance should be celebrated rather than overshadowed by bravado. Layered art appeals to the viewer who enjoys searching for those fine details that require thoughtful consideration to reveal hidden meaning. It calls as much upon visual metaphor as technique to bring its subtlety to the surface.

SLMM members have adopted a holistic attitude about their responsibility as artists and citizens. They are avid readers in a wide field of disciplines and ignore the stereotype that they should only rely upon their visual relationship to the world. Many express themselves in a variety of media and also have productive careers as authors, professors and therapists. They let intellectual curiosity, as well as mindful sensitivity, infuse their work. Furthermore, as creators they recognize the importance of memory as they pursue their studio explorations. Greeks were wise to give mythic importance to the union

Richard Newman

Shrine for Prayers

mixed-media, 27" x 23" x 7"

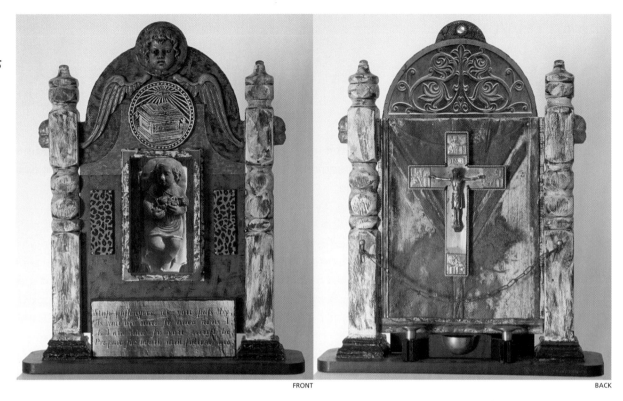

FRONT BACK

of Zeus with Mnemosyne (memory) who together produced the Muses. It is the landscape of memory which Layerists draw upon to give form and significance to their artful discoveries.

As I reflect upon two decades of my association with SLMM and examine the experiences we have shared and the work we have produced I feel a commitment to a larger goal. Our goal has been to communicate that art is primarily a healing process that charts the way we can realize a more humane world: a world which values art as an agent of transformation; a world which leads people to act compassionately toward their fellow creatures, both great and small; a world which treasures cultural diversity and encourages tolerance at all levels.

The Art of Layering: Making Connections, published by the Society of Layerists, clearly documents the wealth of insight and imagination that the membership possesses. I am confident it can touch the deep reservoir of heuristic knowledge that we depend upon to maintain our balance in this complex and unsettling age.

Richard Newman, President
The Society of Layerists in Multi-Media, 2003

THE HOLISTIC PARADOX

BY JOHN BRIGGS, PH.D.

Creativity is that force within each of us that allows us to formulate what painter Piet Mondrian called "the individual-universal equation." The equation celebrates the paradox that each of us is both isolated and individual *and* universal and indivisible from the whole.

Is the paradox a trivial truism? Look around and contemplate how much of our society and culture is built on the presumption that only the first half is real: that we are separate individuals who are born and must die, and who struggle to survive and assert our existence in between. The second half, which asserts our indivisibility from the whole, receives mainly lip service, the status of a platitude—a grand abstraction, difficult, if not frightening, to focus on. From time to time we feel our deep connectedness, or identity with the world—nature or other people—but for the most part we experience the world as out there, a realm of others and objects resisting us and thwarting our will.

In our psychological lives the two parts of the paradox are split apart across the churning of our psychological complexes. The one great exception to this splitting lies in artistic expression. Throughout the creative process and in its final product, the two parts of the paradox remain fused so that at the very moment the artist achieves her most universal expression of her perceptions, she also achieves her ultimate authentic expression of herself as an individual. This is what is meant by the universality of great works of art. King Lear is both a unique character and a character who expresses the universal human dilemma, as do the agonized faces of *Guernica.* Yet no one could have created these works but Shakespeare and Picasso.

The existential paradox might properly be called our *Primal Nuance* to emphasize the fact that each of us is unique, a "nuance" of the whole from which we come. Each of us sees that line joining (and separating) our individuality and our indivisibility from a subtly different angle. Our bodies and minds are made up from the cosmic dust of the big bang. Our DNA molecules connect us to the whole history of evolution and each of us expresses that history in a slightly different way. Our consciousness is a microcosm of human consciousness. We are a nexus of the creative processes that have made the material world. In one sense, all living creatures are embedded in the existential paradox, but our human consciousness makes the paradox a crisis, or at least an urgency.

On one side of the boundary which is our Primal Nuance lies the realm in which we are individual, conditioned beings. On the other side is what has been variously called the unconditioned, the unknowable, the whole, the implicate order. Chaos Theory as well as Quantum Theory tell us that the idea of parts and objects breaks down at a certain point so that

John Briggs

God's Eye

Velvia film photograph, digitally scanned
and archivally printed, 14" x 14"

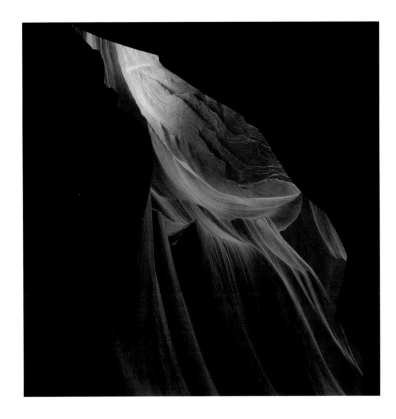

even the expression "everything affects everything else" has to be taken with a cosmic grain of salt. We have not the smallest idea of all the "things" involved or the laws connecting them within the whole, nor are we likely to get to the bottom of them. Physicist David Bohm described the whole as the realm of no-*thing*-ness, where what is at play can't be confined within the subject and object categories of thought. It is the indivisible.

Death often brings the paradox into awareness because it's the individual who dies while All Else goes on. In the moment of grief we recognize in the individual some contact with the universal. We appreciate what made that individual unique and unique for us when the individual and the universal come together with an excruciating, incomprehensible depth. It is no accident that at such moments people often feel the impulse for creative expression. In the impact of death, people who have never "been creative" write poems or paint pictures. They set up memento-filled monuments to the individual lost, as happened on the fence of St. Paul's Church after the collapse of the World Trade Center towers.

In her poem, "There's a Certain Slant of Light," Emily Dickinson gives us an eloquent account of the feeling of the Primal Nuance where the individual meets the universal.

There's a certain Slant of light,
Winter Afternoons—
That oppresses, like the Heft
Of Cathedral Tunes—

Heavenly Hurt, it gives us—
We can find no scar,
But internal difference,
Where the Meanings, are—

None may teach it Any—
'Tis the Seal Despair—
An imperial affliction
Sent us of the Air—

When it comes, the Landscape listens—
Shadows—hold their breath—
When it goes, 'tis like the Distance
On the look of Death—

(From *Acts of Light,* Emily Dickinson, by Jane Langton and Nancy Ekholm Burkert, Boston: New York Graphic Society, 1980)

The experience of our Primal Nuance usually finds its way to us through creative expression, which may be making something, being moved by a work or art, or by nature—there are countless ways. As Dickinson shows in her poem, the experience goes beyond words. We can see the poet struggling to express the Existential Paradox by using paradoxical language. What for example is the feeling of being oppressed by the cathedral tunes? What is an "imperial affliction"? Is this a wound, a disaster or a profound gift?

The mission to make the individual-universal equation takes the artist back to the tradition we first see in ice age cave paintings, Neolithic sculptures of women, or bone flutes. Recent discoveries that even the Neanderthals made art suggest that our most essential hominid heritage may not be our tool making ability so much as our need to make art~the need to express and share with our fellows the curious dilemma of the curious reality where we have found ourselves.

The Layerist aesthetic and practice encourages artists to work on the chaotic and unknowable boundary of the existential paradox. In doing so, Layerists recognize explicitly what many artists have forgotten: that the expression of the Primal Nuance is, at its root, a spiritual mission. And the mission is sacred.

John Briggs, Ph.D.
Professor, CSU, Department of English Language
Western Connecticut State University, Danbury, CT,
author of *Fire in the Crucible, The Alchemy of Creative Genius,
Fractals: The Patterns of Chaos*

Introduction

THE ART OF LAYERING

BY MARY CARROLL NELSON

While observing and writing about art over the years, I've noticed that certain artists answered almost exactly the same way when I asked them about their inspirations. They would cite the unifying ideas circulating in western society, especially those theories of psychologist Carl C. Jung and Einstein's theories related to physics. Jung posited that "the collective unconscious" is a repository for human memory and primordial archetypes. He believed we all have access to the same information through an archaeological exploration of our own consciousness. Einstein's theory of relativity and the ensuing quantum theories of new physics suggest that the essence of the universe can be expressed as energy. Such concepts had deeply affected my own thinking, so I was alert to the fact that these other artists shared an interest of my own. They were diverse in their approach to creating art, but they seemed to be including similar references to various disciplines in the sciences, philosophy and metaphysics. Their effort was to harmonize an array of ideas for philosophical as well as aesthetic reasons. In the mid-1970s, I began thinking of their work as Layered and spoke of them as Layerists. Layerists are responding to their perception that we live in a dynamic universe characterized by relationships of energy, thought and image. In 1982, I founded the Society of Layerists in Multi-Media to serve as a network for artists who express a similar interest in a holistic worldview.

The holistic worldview has gained currency, not only in art but also within the human psyche ever since the publication of the Apollo photograph of Earth from space in 1972. We can now visualize this gorgeous planet as a single unit, without visible boundaries separating countries and peoples. We are, I propose, in a different stage of awareness than we were before that image of the beautiful "Blue Marble" was implanted in our memories. This potent symbol has altered our visual perspective forever. I believe this picture signals the appropriateness of a holistic perspective to a new age of inner and outer exploration.

The layering process is individualistic, but there are relationships among Layerists' techniques. They frequently add or take away material, layer by layer, as an analogue for aspects of nature, such as sedimentation, erosion, passage of time, recession in space, radiation of light, or energy, simultaneity, synchronicity, and the cycle of birth, death and rebirth. Their methods are often complex for reasons other than creating an image. The act of making the layered work takes on a ritual quality.

Layering is an art of synthesis which benefits from earlier art developments—Symbolism, Surrealism, Expressionism, Cubism, Abstract Expressionism—that were devoted to probing the psyche for image and metaphor. Distinctly modern materials and processes allow Layerists to create collages, assemblages and other multi-media works with excellent adherents, ink jet printers, acrylic paints and binders, and new modeling clays. Yet, Layering as a mode of thinking about art applies also to pure watercolors and oil paintings, classical printmaking, traditional ceramics and bronze sculpture that depend upon time-honored techniques. Therefore, we say that it is not the technique that distinguishes a Layered work of art so much as the mind of the artist who creates it. The layers we refer to are both physical and metaphorical. Layering is an evanescent art, a subtle collection of thoughts brought into relationship through the connections of the artist's mental filter.

The layer, whether tangible or subliminal, is recognized by the artist as a formal quality in the artwork. Layerists might work transparently so that each layer remains visible from the surface, or they may overlay images that are partially or wholly hidden by successive layers. Sometimes they bury words, symbols, or objects that enhance their intention to create a healing artwork which serves as a prayer as well as an image. Layerists frequently explore the shadow, those dark depths in our memories; however, layered art is an affirmative, communicative alternative to "art about art" and nihilism.

Most Layerists are mature, proficient artists who have achieved a meditative level of creativity. They imbue their work with meaning. Layerists have usually had a moment of discovery, a "Eureka!" in their lives when suddenly they became aware of their connectedness to All That Is. These personal encounters have led them to a holistic perspective. The unique quality of each artist's discovery accounts for the diversity of Layering, which grows from the integration of a perception of ultimate connectedness with the flowing, on-going nature of living consciously.

The words whole, holistic, holographic and holism, like health and healing, come from the same Middle English root *hal*. They relate to oneness and unity, which contrast with separation and disharmony. Because of its holistic intention, Layered art has a spiritual dimension that viewers will perceive in *The Art of Layering: Making Connections*.

Mary Carroll Nelson, Founder
The Society of Layerists in Multi-Media, 2003

THE HISTORY OF THE SOCIETY OF LAYERISTS IN MULTI-MEDIA

BY SUSAN H. McGARRY

From the founding of The Society of Layerists in Multi-Media in 1982, the group has organized annual and regional conferences and exhibitions exploring elements and themes that weave throughout the artists' works. Below is a list of books and tapes that have documented these efforts, most of which are no longer available. The list of exhibitions evidences the continuing themes that inspire the artists, as well as the museums, art centers, galleries, colleges, churches and alternative spaces that have hosted SLMM exhibitions

Books, Tapes & CDs

Fire in the Heart: The Creative Spirit, CD, Schneider Museum of Art, Southern Oregon University, Ashland, OR,

Bridging Time & Space, Essays on Layered Art, hardcover book edited by Ann Hartley, Markowitz Publishing, Maui, HI, 1998 (out of print).

Artists of the Spirit, National Symposium, The Walton Arts Center and Fine Arts Gallery, University of Arkansas, Fayetteville, AR, audio tapes of symposium speakers: Patricia Brown, Meinrad Craighead, Gilah Yelin Hirsch, Pat Musick, Richard Newman, Miguel Angel Ruiz, Peter Rogers and Melissa Zink, Sounds True Recordings, Boulder, CO, 1994 (out of print).

Affirming Wholeness: The Art and Healing Experience, National Symposium, University of Texas Health Science Center, San Antonio, audio tapes of symposium speakers: Jacob Liberman, Mary Earle, Eleanor S. McCulley, Mary Ellen Bluntzer, Jeanne Achterberg and John Briggs, Sounds True Recordings, Boulder, CO, 1992 (out of print).

Layering—An Art of Time and Space, catalog edited by Ann Hartley, The Society of Layerists in Multi-Media, Albuquerque, NM, 1991 (out of print).

Layering, video tape edited by Mary Carroll Nelson, Schneider Creative, Albuquerque, NM, 1990 (out of print).

Exhibitions

2004

Bridging Time and Space: California Layerists Create, California Regional, SomArts Bay Gallery, San Francisco, CA

Stratum/Strata, Northeast Regional, Liebig Gallery, Mystic Art Association, Mystic, CT

Healing Environments, Blue Moon Gallery, Hot Springs, AR

Colorado Regionals, Karen White Gallery, Denver, CO, and Emmanuel Gallery, Denver, CO

2003

Fire in the Heart: The Creative Spirit, Schneider Museum of Art, Southern Oregon University, Ashland, OR

SLMM Show, University of Colorado Gallery of Contemporary Art, Colorado Springs, CO, 2001

Layered Images, New Mexico Regional, South Broadway Cultural Center, Albuquerque, NM

Landscape and Memory, Sedona Center for the Arts, Sedona, AZ

Expressions of Change: Selections from the Society of Layerists in Multi-Media, California Regional, Chico Art Center, Chico, CA

Shadow and Light, New Mexico Regional, South Broadway Cultural Center, Albuquerque, NM

Earth Spirits, Hiestand Galleries, Miami University, OH

Tides of Change, Texas Regional, Rockport Center for the Arts, TX

Selections from the Society of Layerists in Multi-Media, Colorado State University, Colorado Springs, CO

Alchemy (Rolled Art), Rosalind and Alfred Lippman Gallery, Congregation B'nai Jeshurun, Short Hills, NY

The Birth of Wisdom, La Chapelle Des Penitents, Gordes, France, and St. Johns College, Santa Fe, NM

Matters of the Heart, Michigan Regional, Art on the Hill Gallery, Grand Rapids, MI

Musings for the Millennium, Ohio Regional, Pomerene Center for the Arts, Coshocton, OH

Alchemy (Rolled Art), Nabisco Headquarters, East Hanover, NJ; Garde Art Center, New London, CT

Bridging Time and Space: The Power of Image and Word, Dominican College, San Rafael, CA

Celtic Connections, Laura Knott Art Gallery, Bradford College, MA

Guardian Spirits, St. Peter's and St. Paul's Church, Marlborough, England

The Tree of Life, Instituto Allende, San Miguel de Allende, Mexico

Layers: Mining the Unconscious, Western New Mexico University, Silver City, NM

Crossings, The Open Art Center, Old Saybrook, CT

1995

Layers of Life, Reynolds-Heller Gallery, Columbus, OH

Crossings, St. John's College, Santa Fe, NM; Bradford College, MA, and Greeley, CO

1994

The Layered Perspective, The Walton Arts Centers and Fine Arts Gallery, University of Arkansas, Fayetteville, AR

Southwest Visions, Johnson-Humrickhouse Museum, Roscoe Village, Coshocton, OH

SLMM Members Group Exhibition, Fuller Lodge Art Gallery, Los Alamos, NM

Crossings, Laura Knott Art Gallery, Bradford College, MA

1993

Layering, Dartmouth Street Gallery, Albuquerque, NM

Layering, Ohio Regional, Denison Art Gallery, Denison University, Granville, OH

1992

The Universal Link and Art is for Healing, University of Texas Health Science Center, San Antonio, TX

1991

The Society of Layerists in Multi-Media, New Mexico Regional, Fuller Lodge Art Center, Los Alamos, NM

The Healing Experience, Laura Knott Art Gallery, Bradford College, MA

Layering, A Gathering of Voices, Marin County Civic Arts Galleries, San Rafael, CA

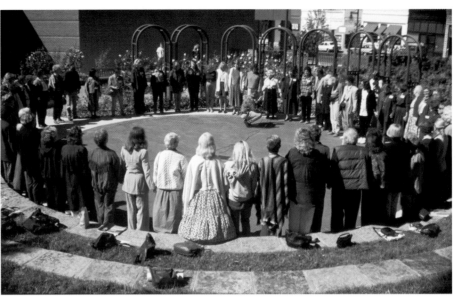

SLMM Prayer Circle, Fayetteville, AR, 1994

1990

Layerists, Level to Level, Johnson-Humrickhouse Museum, Roscoe Village, Coshocton, OH

1988

Shrines and Sacred Places, New Mexico Arts and Crafts Fair, Albuquerque, NM

1987

Layering/Connecting, Zanesville Art Center, OH, and Stifel Fine Arts Center, Wheeling, WV

1985

Layering, An Art of Time and Space, The Albuquerque Museum, NM

ARTISTS' PLATES

COSMIC SOURCE

FIRES *of* LIFE

KNOWLEDGE OF THE HEART

collective consciousness

RESONANCES

Interconnections

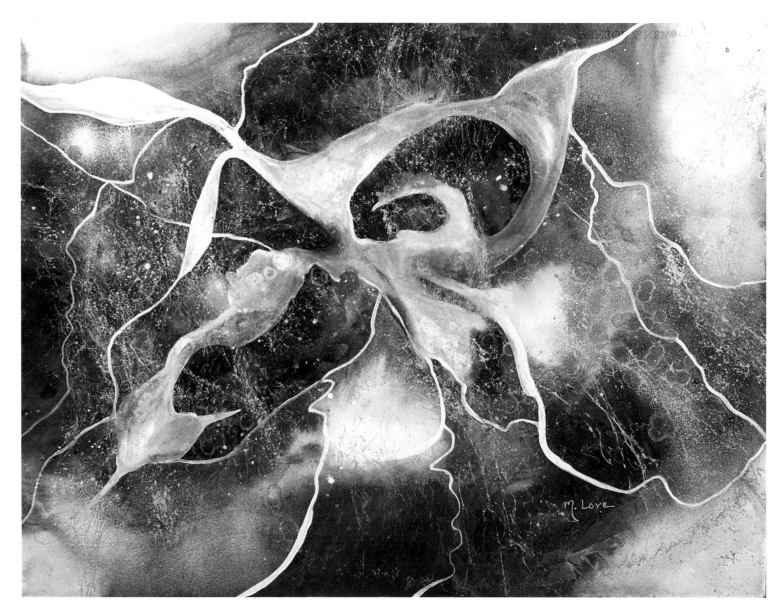

Marianna Love

Streams of Light
watermedia, 22" x 30"

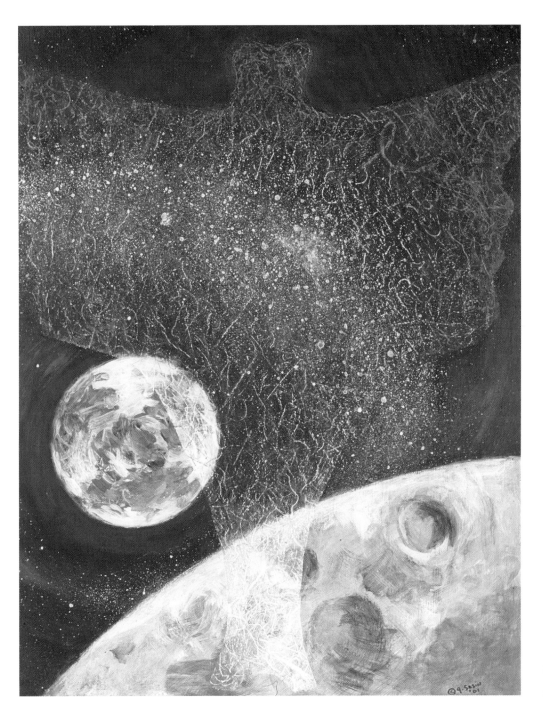

Georgette Sosin

Earth Guardian

acrylic on wood, 20" x 16"

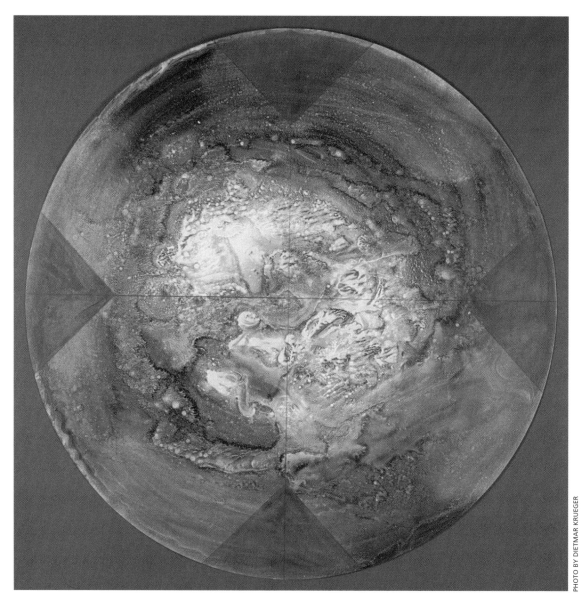

Claudia Chapline

Tondo No. 7, The Unseen World

acrylic on plastic, 30" diameter

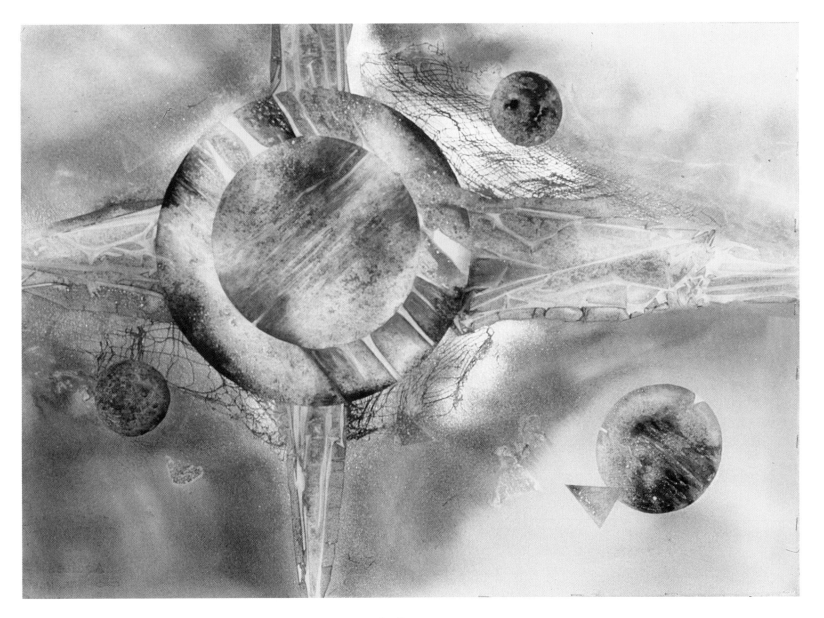

Tara Moorman

Heaven's Gate
watercolor, 22" x 30"

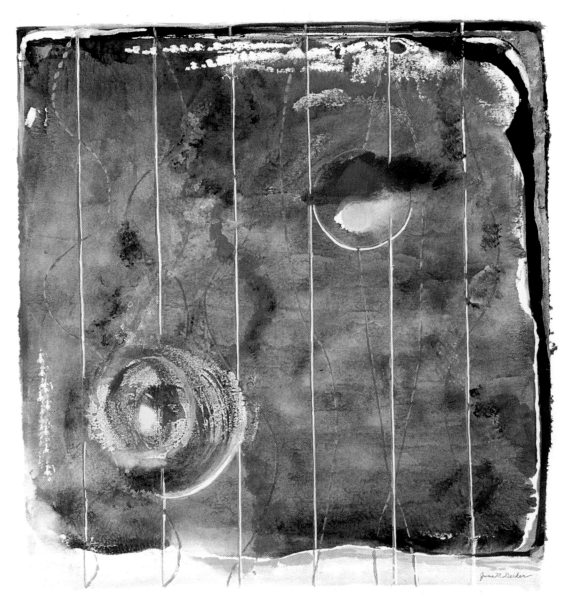

June Decker

Super String Universe Theory
monotype, acrylic, 22" x 22"

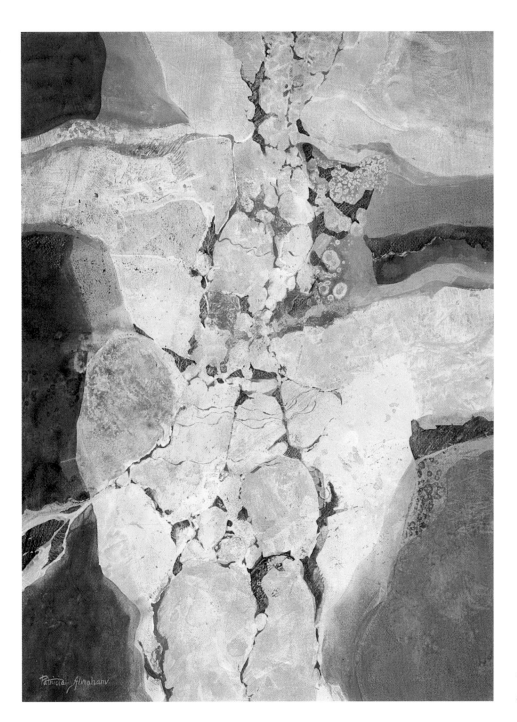

Patricia Abraham

Moonstone Tidepool
acrylic on Fabriano paper, 30" x 22"

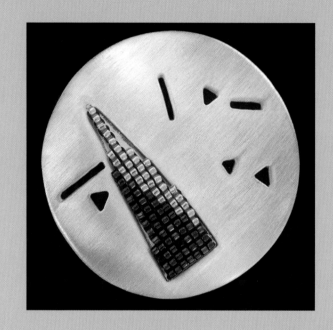

Betty Jo Minshall

Pendant

sterling silver, glass beads, 1.9" diameter

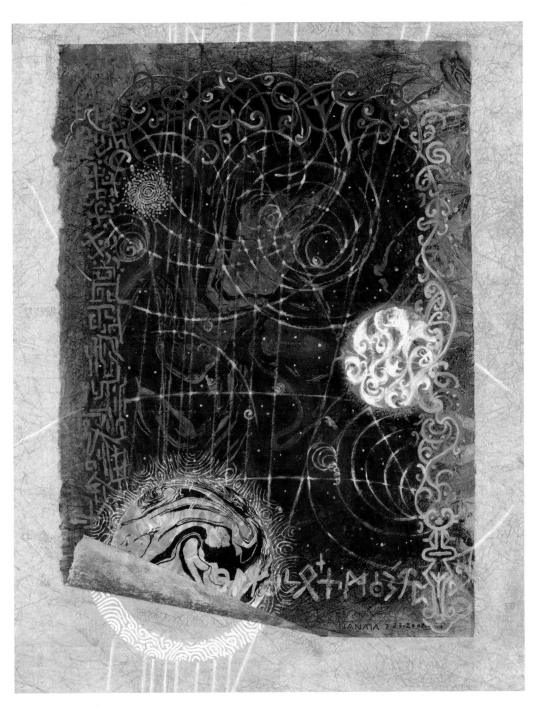

Janaia Donaldson

Emergence
papers, plastic, acrylic, film, 28.5" x 22.5"

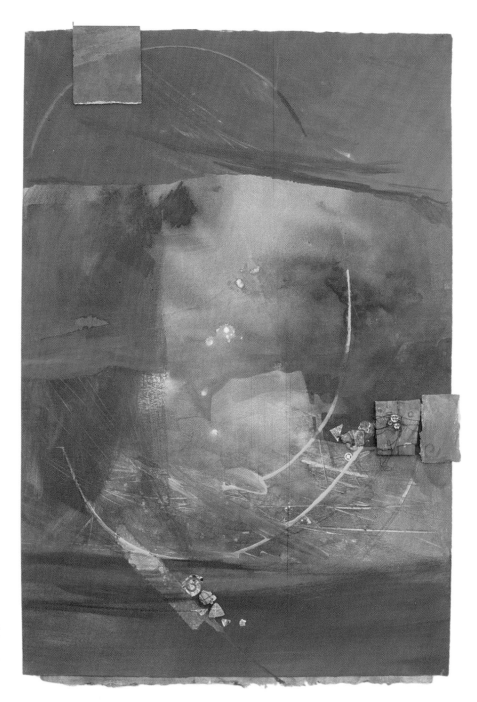

Helen Gwinn

Sacred Gift

acrylic collage (stones, beads, shells,
copper wire) on paper, 22" x 15"

26

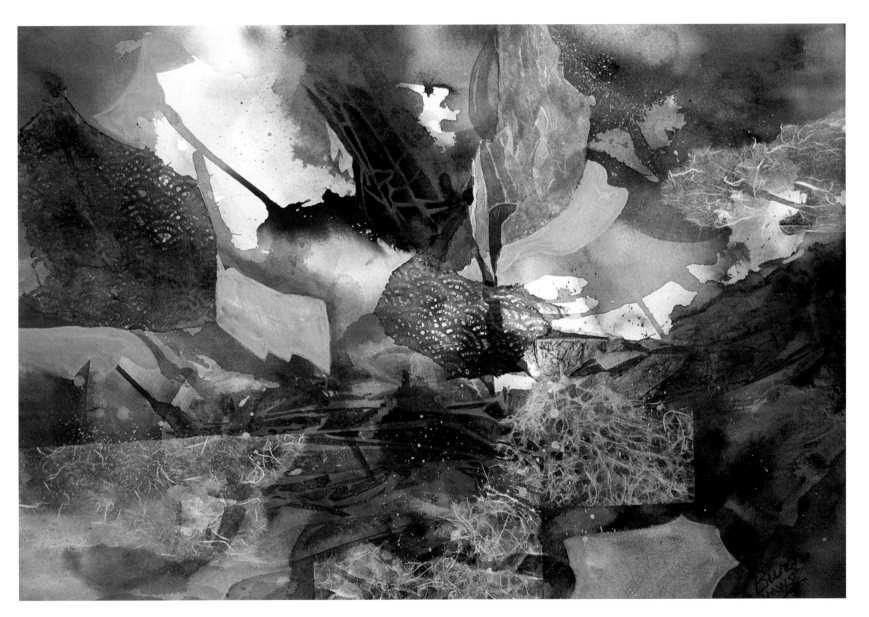

Lynda Burch

Fantasy

watermedia collage, 30" x 37"

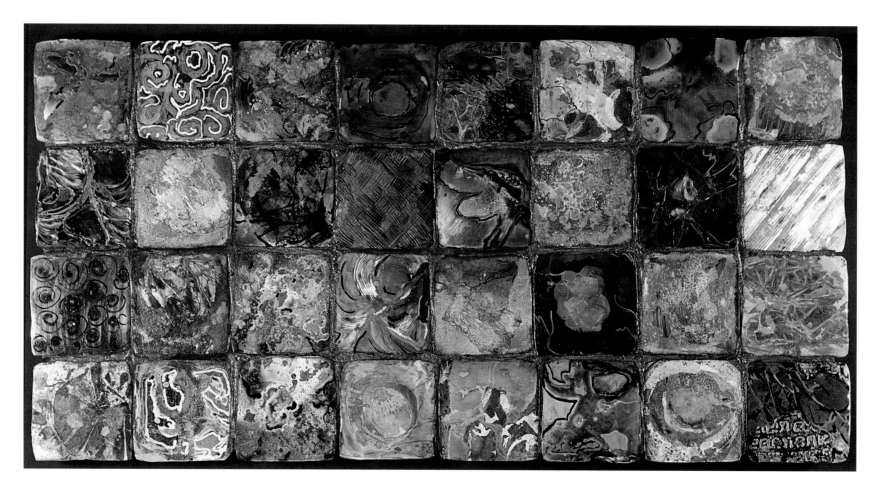

Anne Cunningham

Tiles III

metal (copper, brass, aluminum, mixed media collage), 25" x 49"

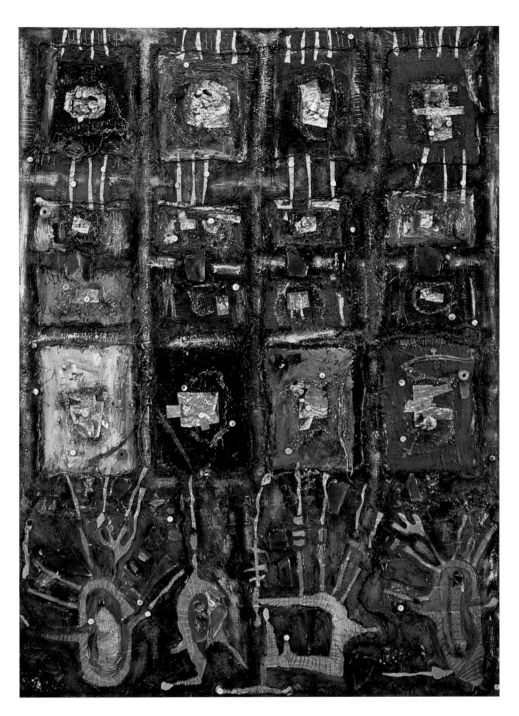

Ruth Bauer Neustadter

Reaching Towards Balance
acrylic, mixed media, 40" x 30"

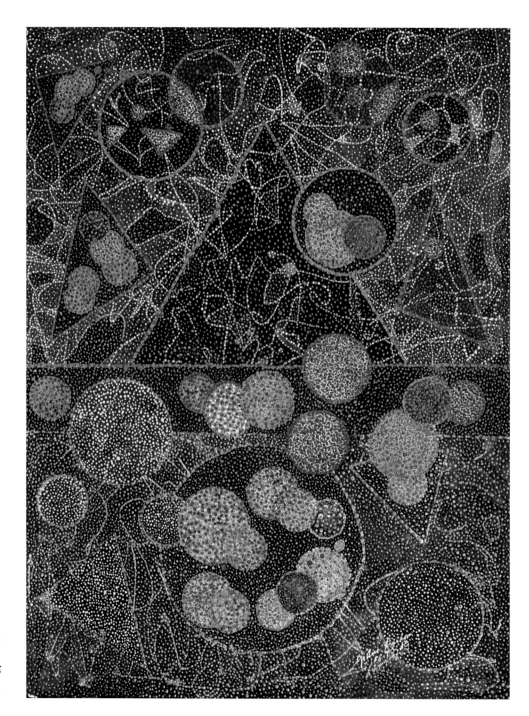

Jo Ann Durham

Cosmos Eternal Symbols

inks, metallics, acrylic, encaustic, 36" x 29"

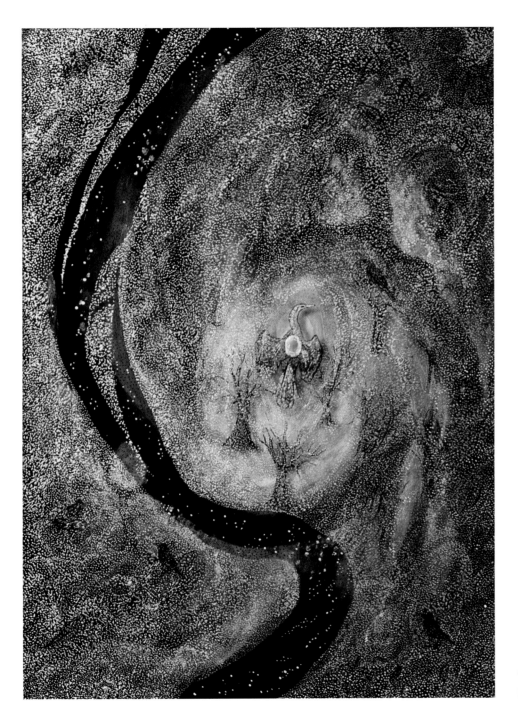

Mary Carroll Nelson

Solstice, Heavenly Ley Series

ink, plexiglas, acrylic, on board, 24" x 18" x 2"

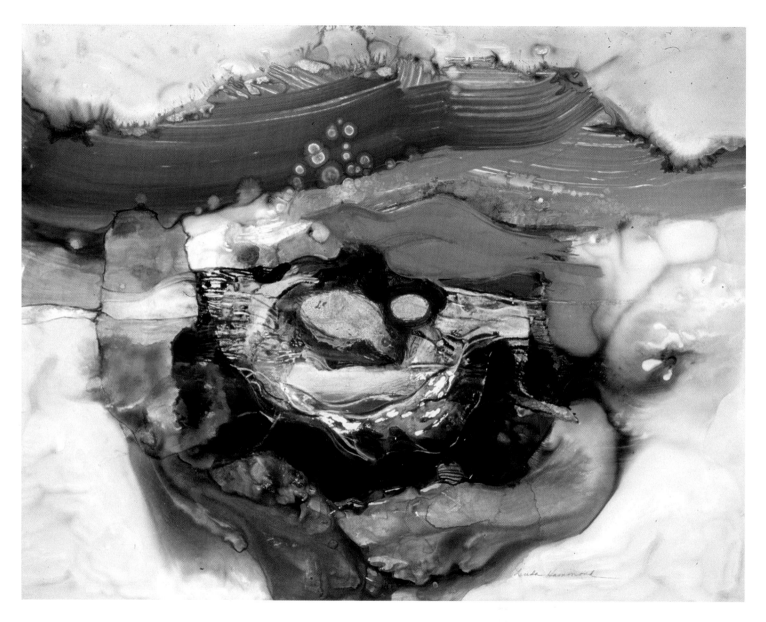

Linda Hammond

Beach Nest II

acrylic, caran d'ache on Yupo paper, 26" x 25"

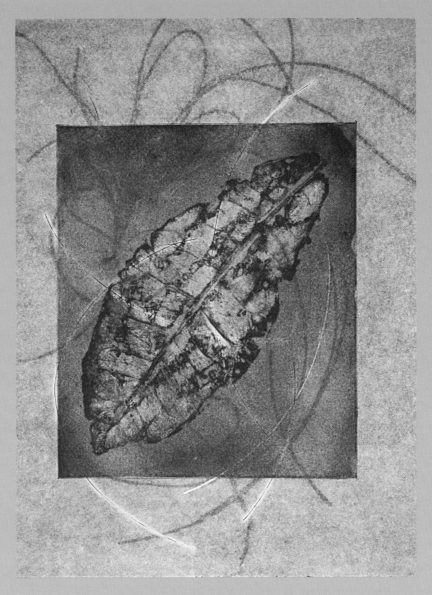

Judy Lyons Schneider

Filament Series

oil based monoprint, 15.5" x 12"

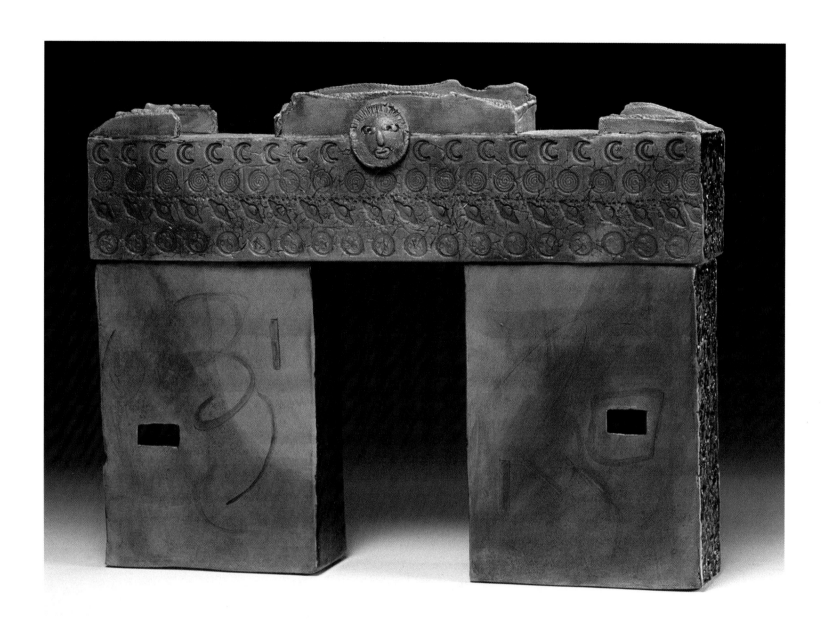

Marilyn Christenson

Portal

clay, 16" x 11" x 3"

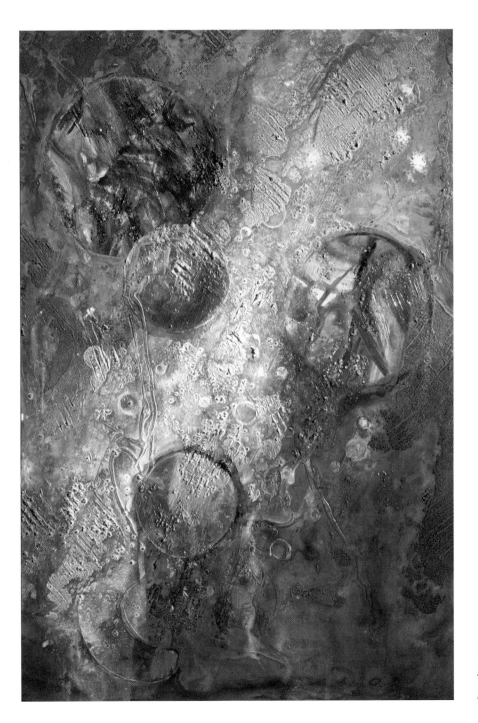

Alexandria Teitler

Solar Music

acrylic, 20" x 16"

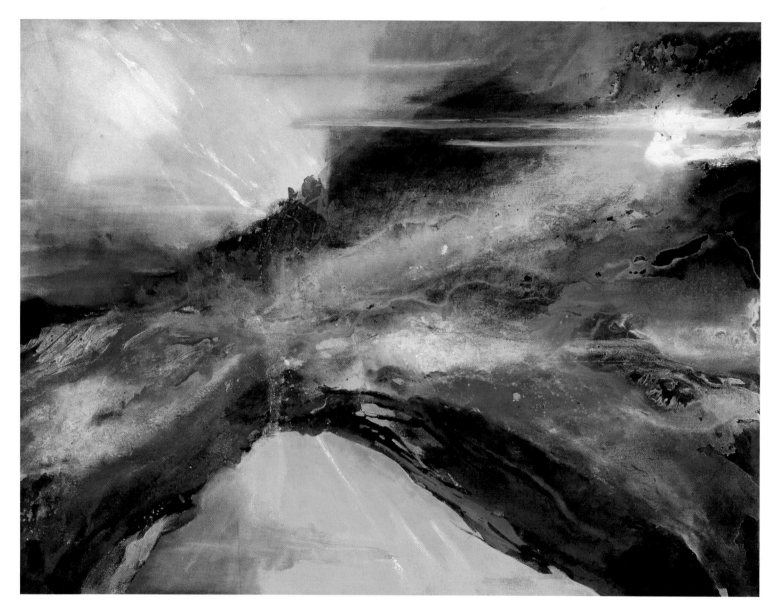

Norma L. Jones

Mystical Splash

acrylic on canvas, 32" x 42"

GAIA

RHYTHMS *of* EXISTENCE

SACRED SPACES

singing the silences

DYNAMIC ENERGIES

Interior Landscapes

inner listening

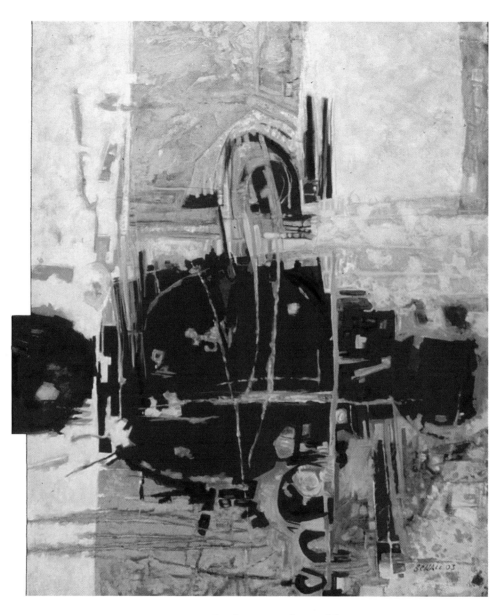

Keith Schall

Charybdis

mixed media, 30" x 48"

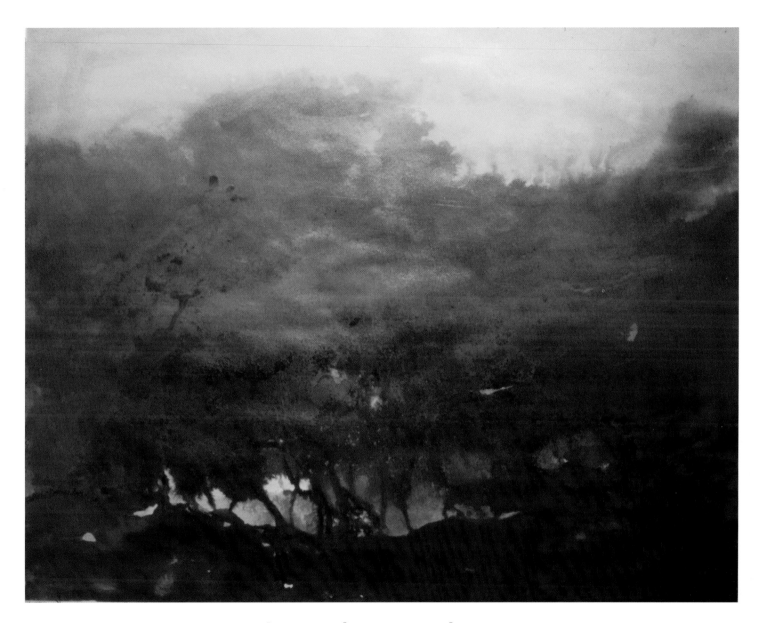

Marie Dolmas Lekorenos

Rage

acrylic inks, 48" x 48"

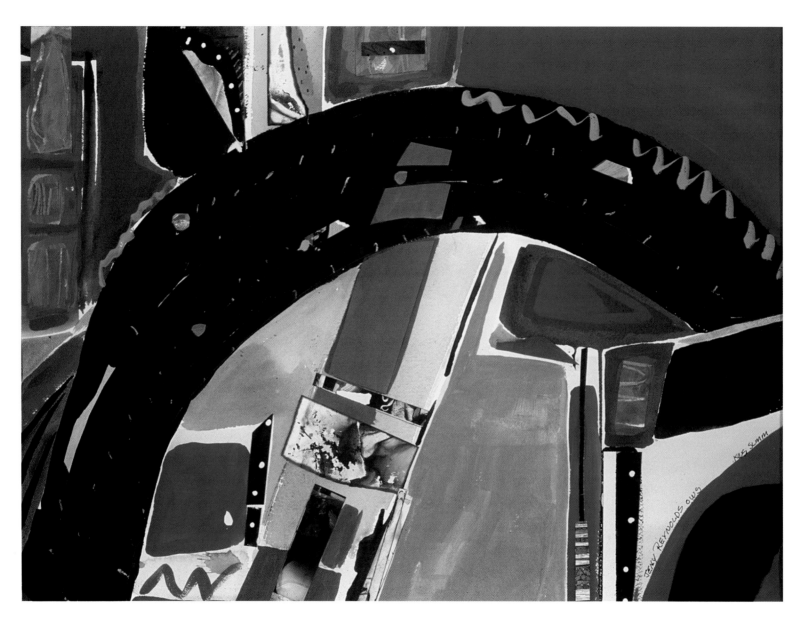

Jeny Reynolds

Canyon Country Arches

watermedia, 28" x 17.25"

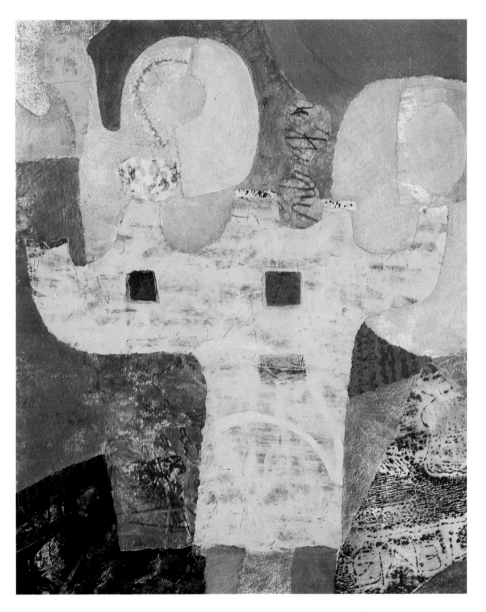

Nancy Egol Nikkal

Cactus 5

mixed media collage, 13.5" x 11"

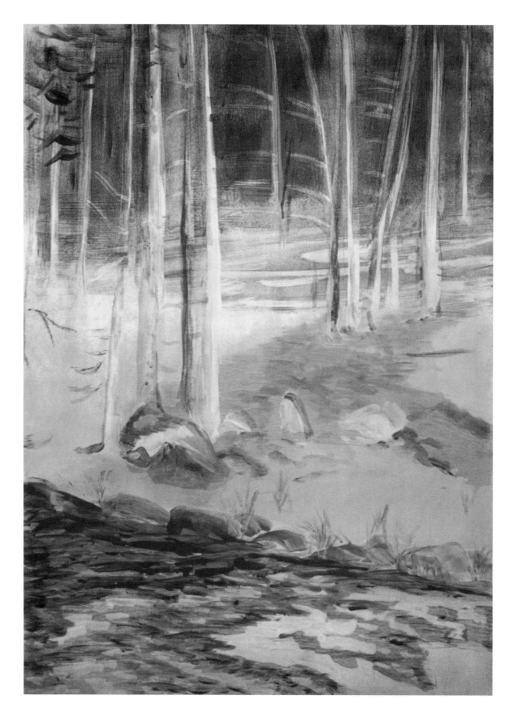

Judith Imm

Looking In
mixed media on wood, 48" x 40"

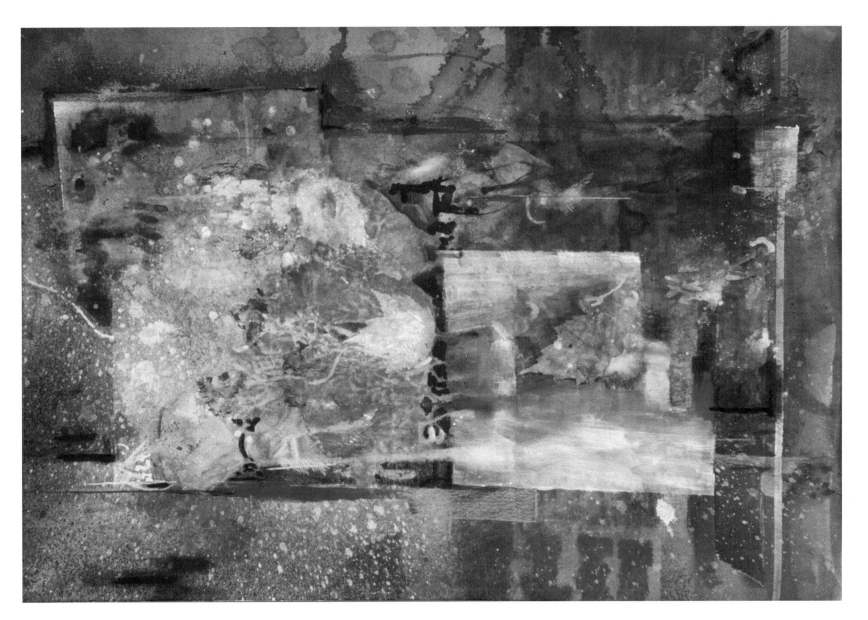

Lynne Kroll

Enigma II

watermedia, 22" x 30"

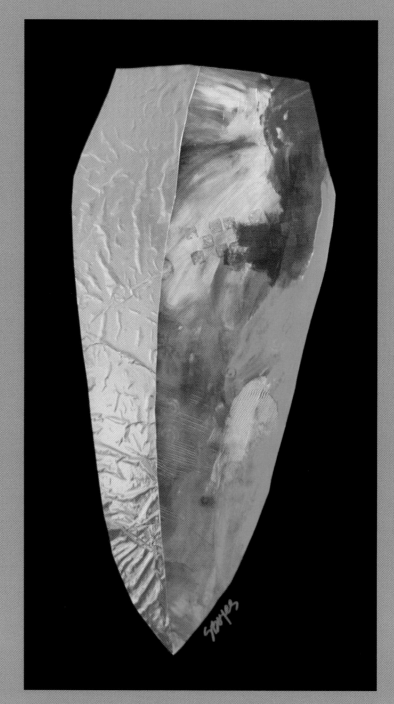

Susan Boyes

Mystic Vase

paste paper, mylar, 20" x 30"

44

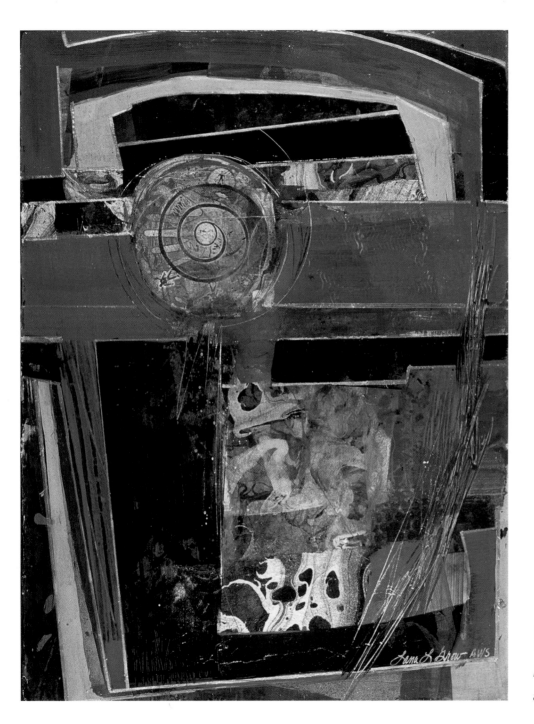

Lana L. Grow

Beyond Your Circle of Imagined Limits
acrylic collage, 22" x 30"

Ilena Grayson

Serenity

ceramic, 12" x 19" x 5"

Suzanne Dunbar Caldwell

Equus

monoprint, 8" x 10"

Carol Bryant

Hey Babe

watermedia, 13.75" x 21"

Evelyn Lombardi Lail

Phantom Return

acrylic, 21" x 21"

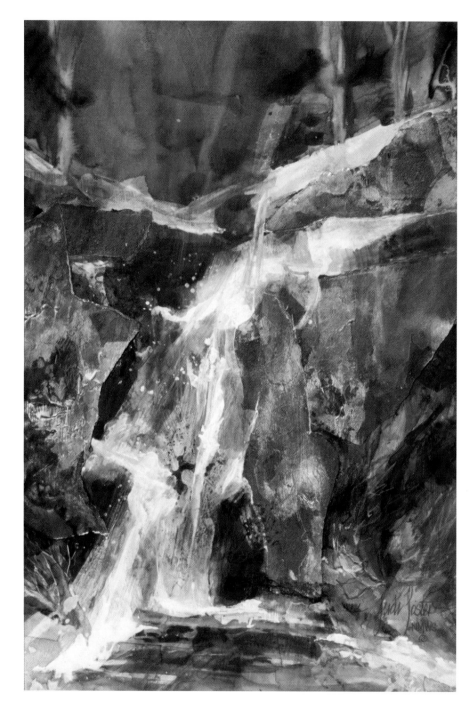

Judi Foster

Jemez Falls
watercolor collage, 24" x 18"

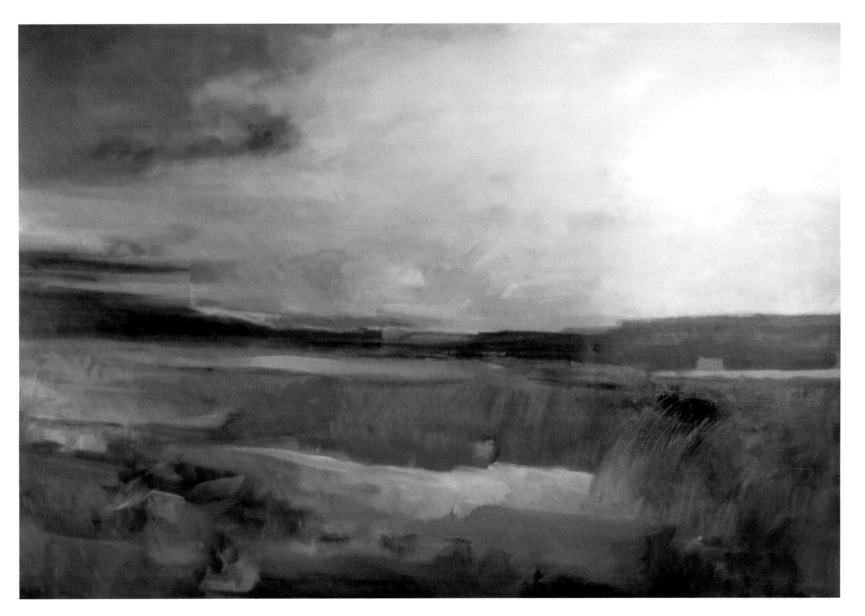

Marlene Lenker

Taos Desert

oil on canvas, 48" x 72"

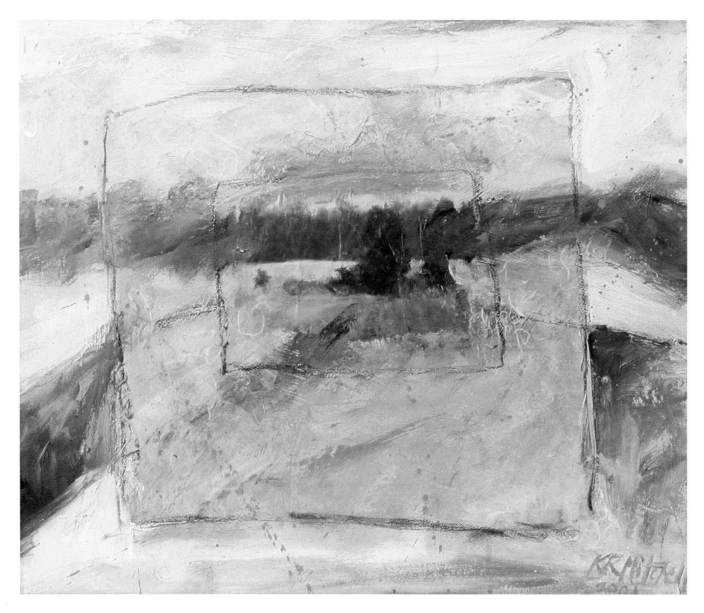

Karen Rand Mitchell

The View From Here
mixed media, 24" x 28"

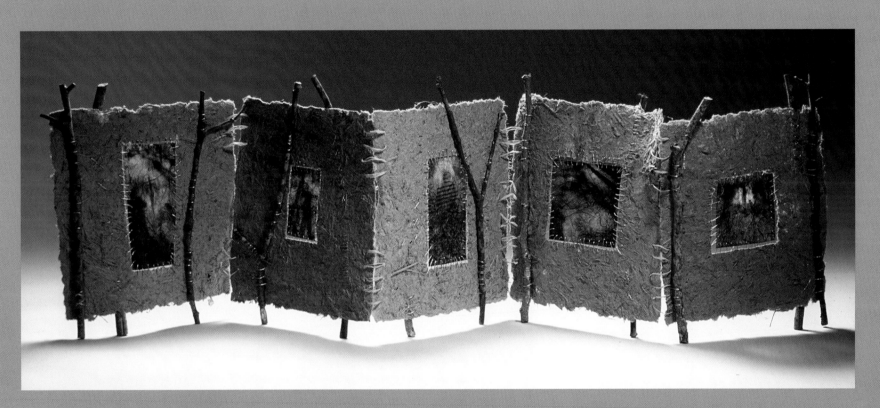

Nancy Lee Dunaway

Solitary Shadows

mixed media artist's book, 8" x 10.5" x 33"

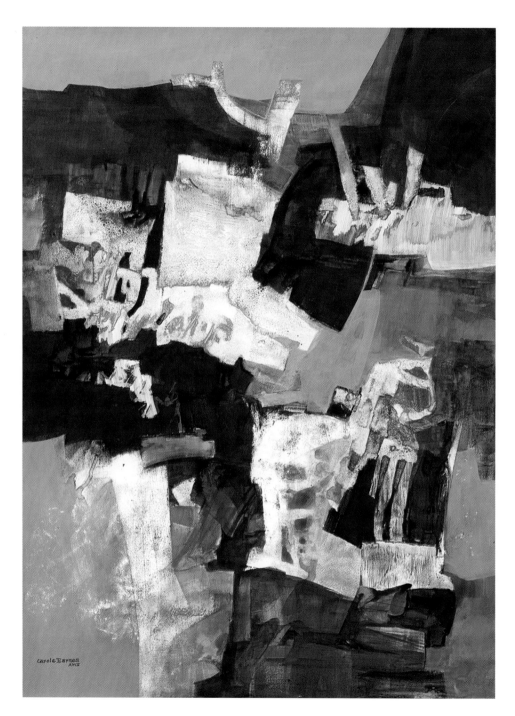

Carole D. Barnes

Canyons of an Ancient Time
acrylic on paper, 30" x 22"

54

Richard Newman

Canyon Emergence

digital print, 18" x 22"

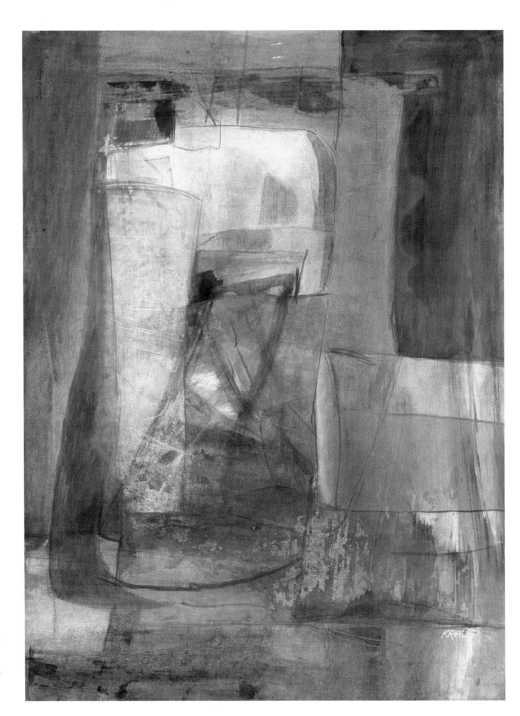

Dusanka R. Kralj
(Reynolds)

Monoliths of Time

mixed media on paper, 30.5" x 23"

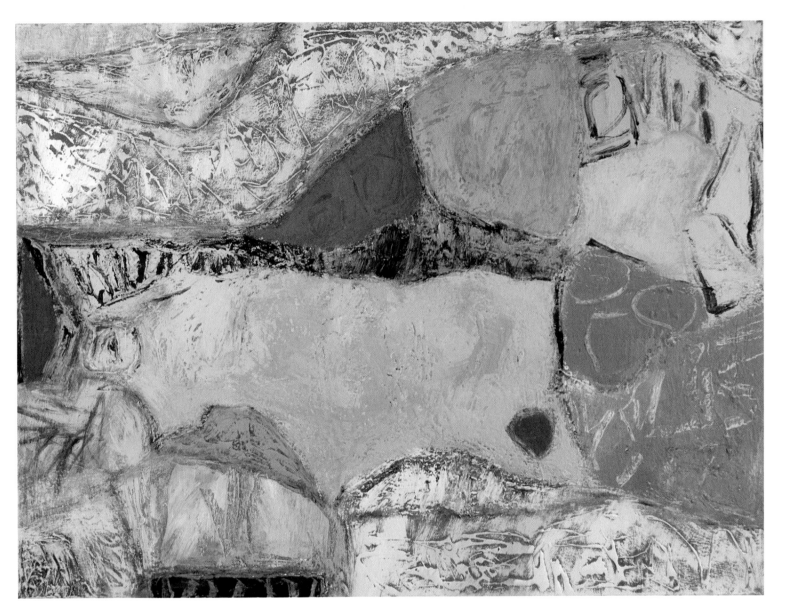

Dail Fried

Echoes of Pompei

acrylic, mixed media on canvas, 30" x 40"

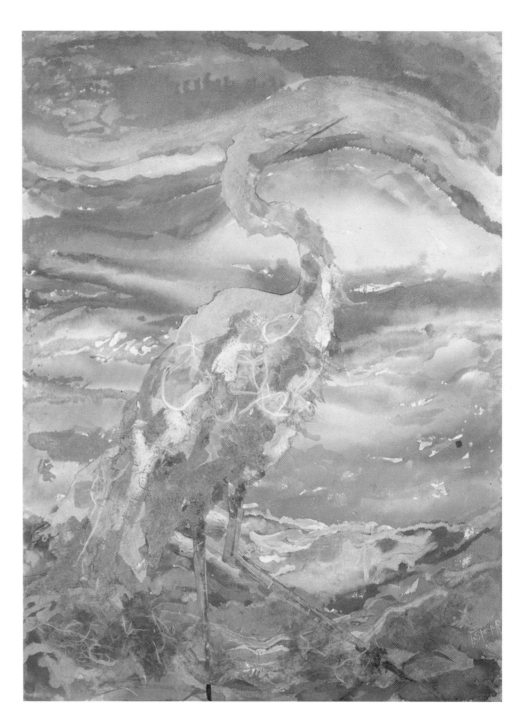

Teddi Steyer

She Greets the Rising Sun
poured inks, mixed collage, 38" x 31"

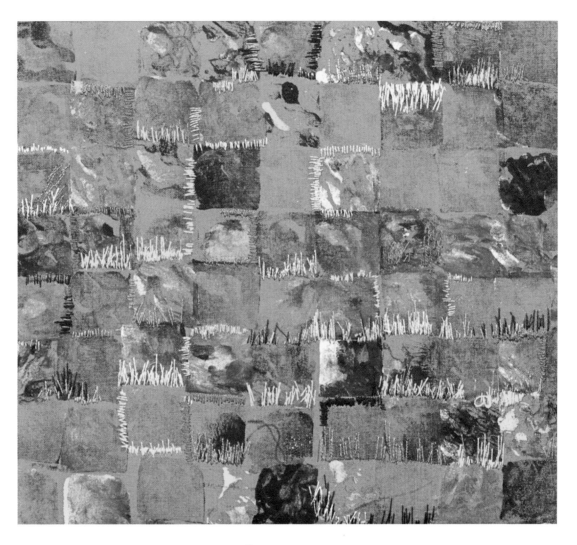

Beverley McInnes

Far Horizons: Islands at Dawn

stitchery on glass (labels, paper, cotton, rayon, silk), 11" x 12"

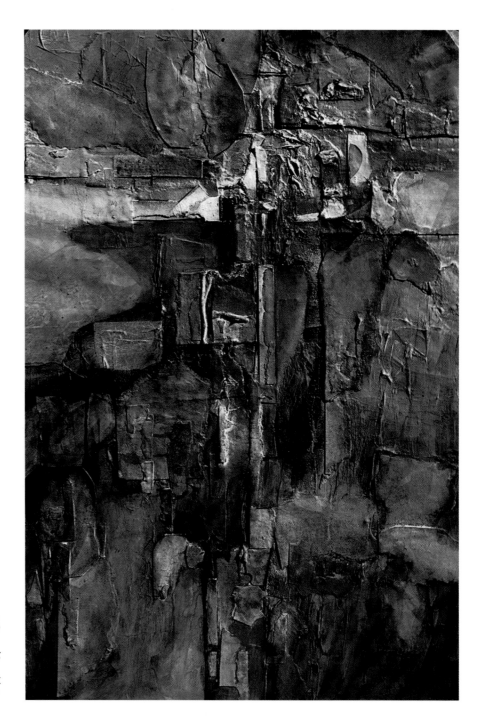

Jan Sitts

Precious Stones

watermedia collage, with joint
compound on canvas, 48" x 60"

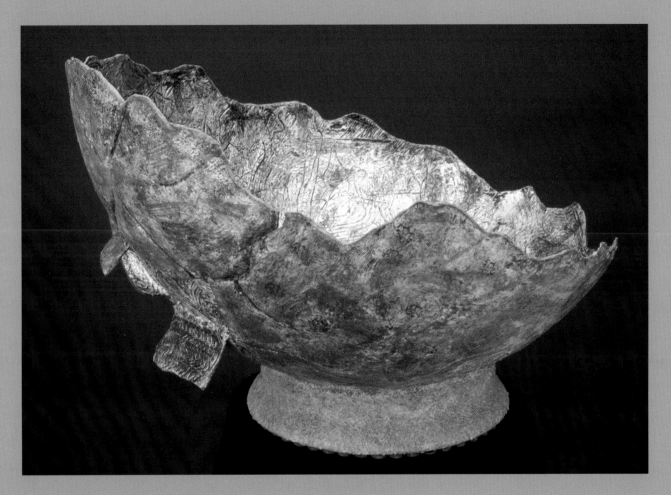

Carleen I. Hearn

Breaking Through

acrylic an paper on paperclay, 17" x 18.5" x 12"

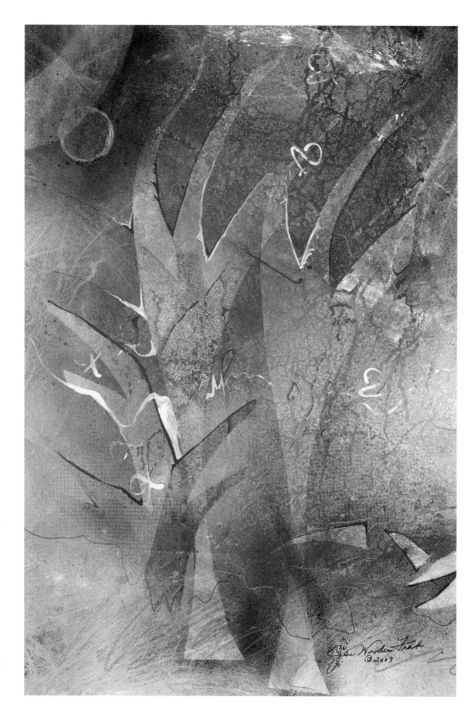

Jane Winders Frank

Twilight Trees

mixed media, 30" x 22"

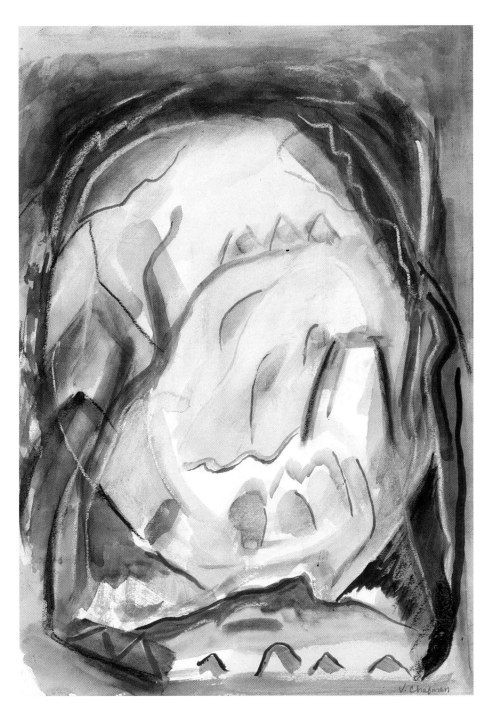

Virginia Chapman

Dream Scene
watercolor, 27" x 20"

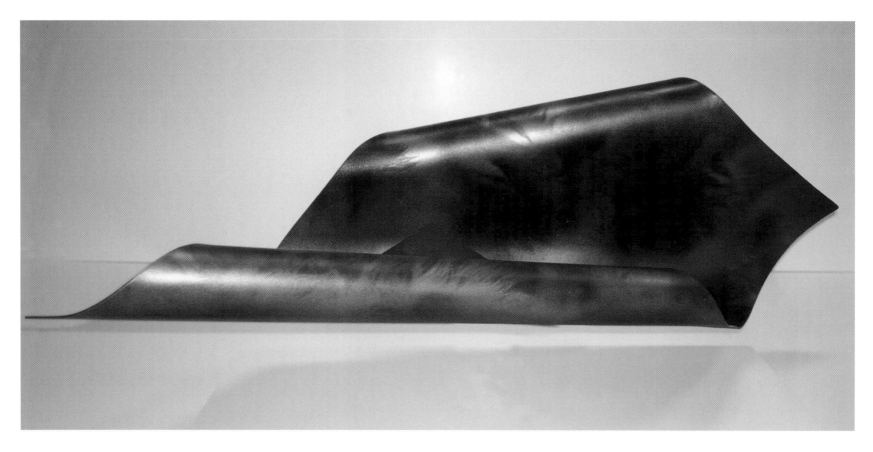

Hilda Appel Volkin

Migration

metal, 20" x 36" x 4"

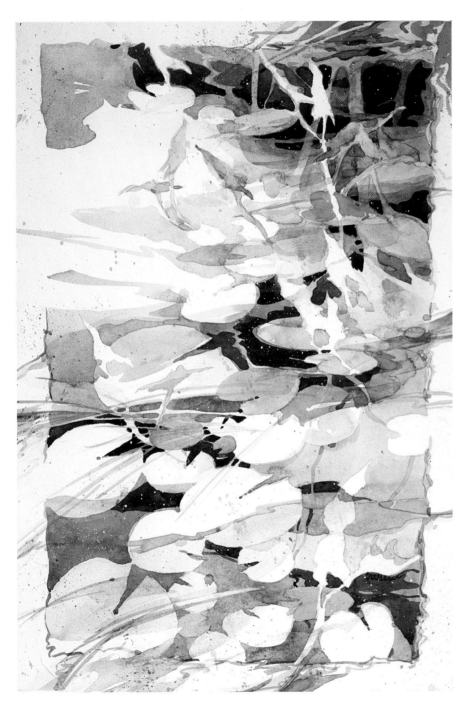

Jean Warren

Waterlilies

watercolor, 22" x 15"

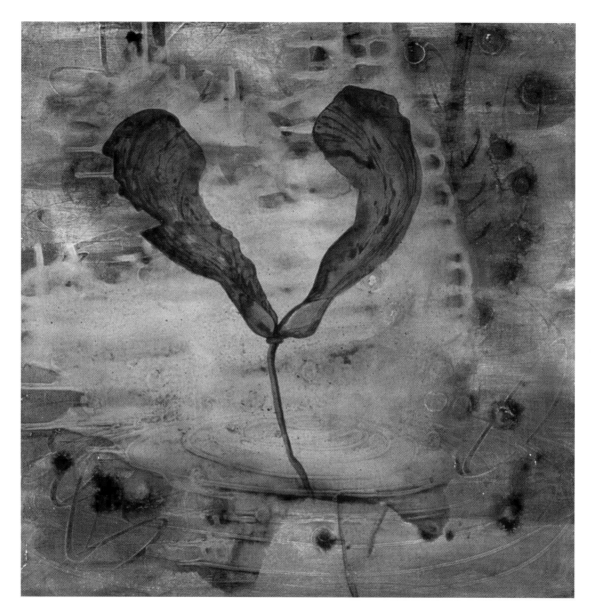

Patti Brady

Winged Seed

acrylic on canvas, 24" x 24"

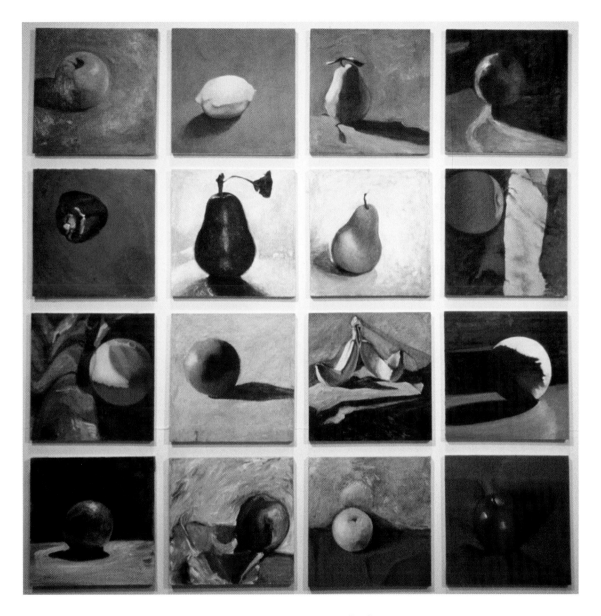

Dawn Wilde

Lite Lunch

oil on gessoed panels, 12" x 12" each panel

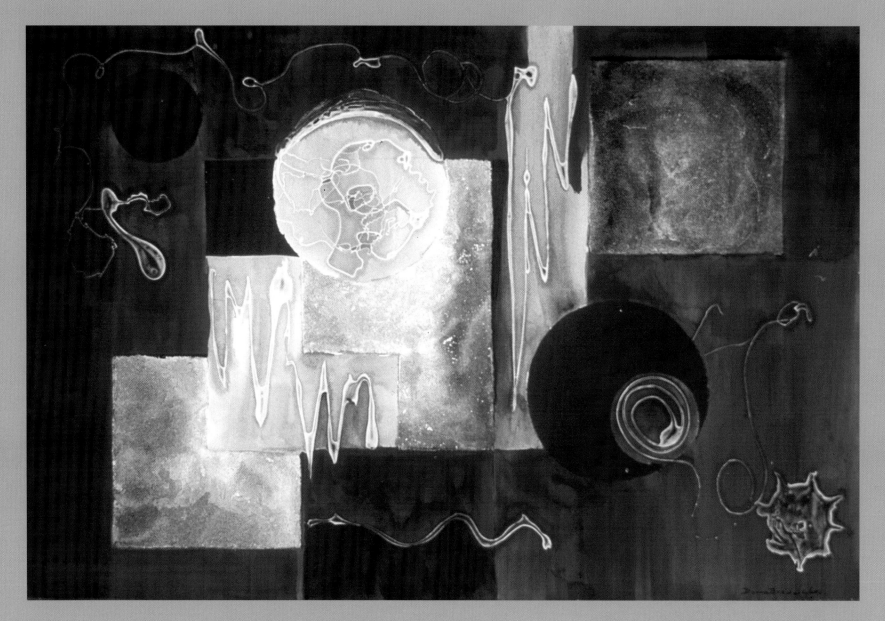

Donna Brower Watts

Morning Song

watermedia collage (paper, sand, gesso, acrylic gel, acrylic) 20" x 30"

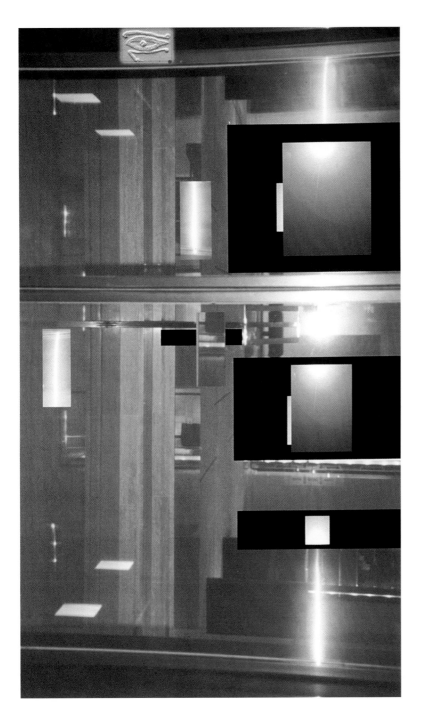

Michelle M. Elle Nicolaï

Infinity

mixed media, 40" x 30"

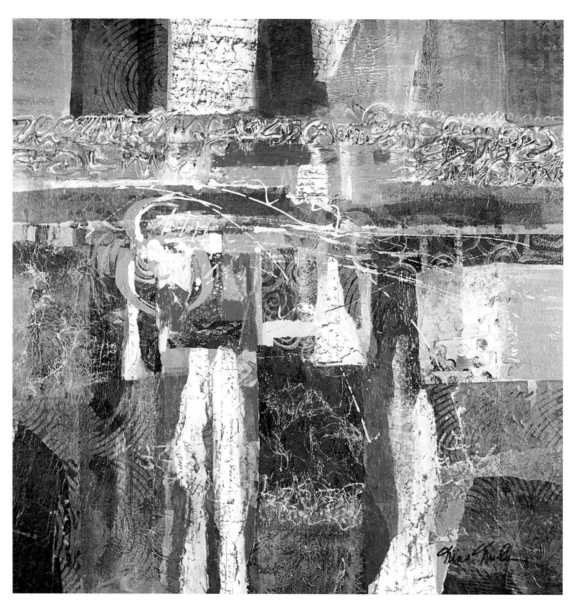

Nina Mihm

A Rosary to Take You Home

watermedia collage, 20" x 20"

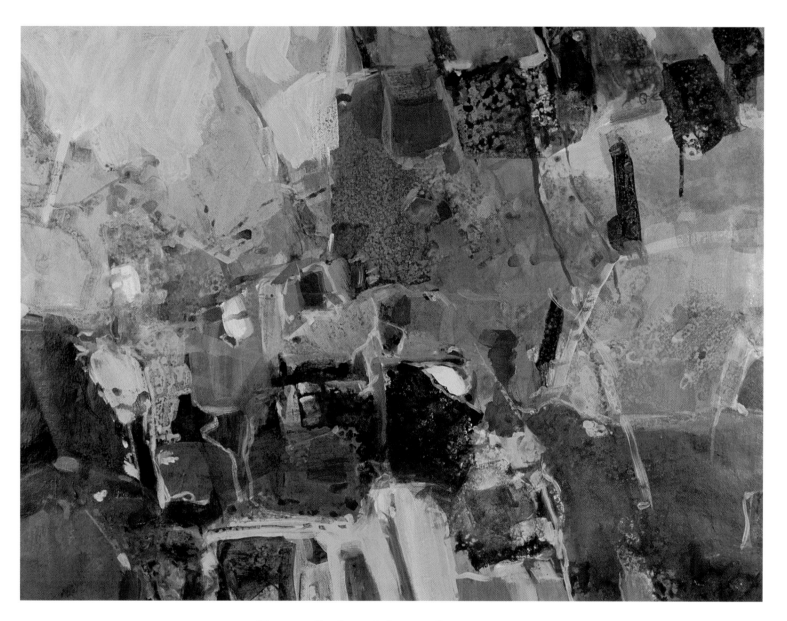

Patricia Harrington

Aerial

acrylic on Aquarius, 28" x 36"

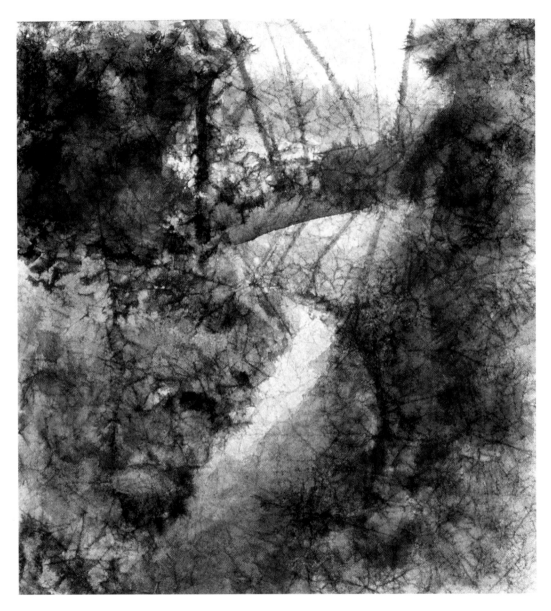

Sheila Sondik

Evening Shadows II

watercolor, sumi, 17" x 16"

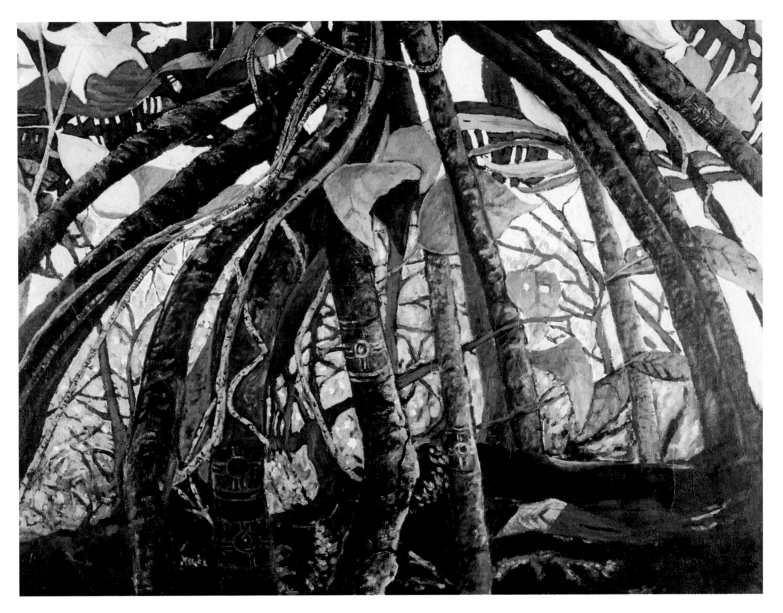

Janet H. Ruffin

Rain Forest

acrylic, 38" x 50"

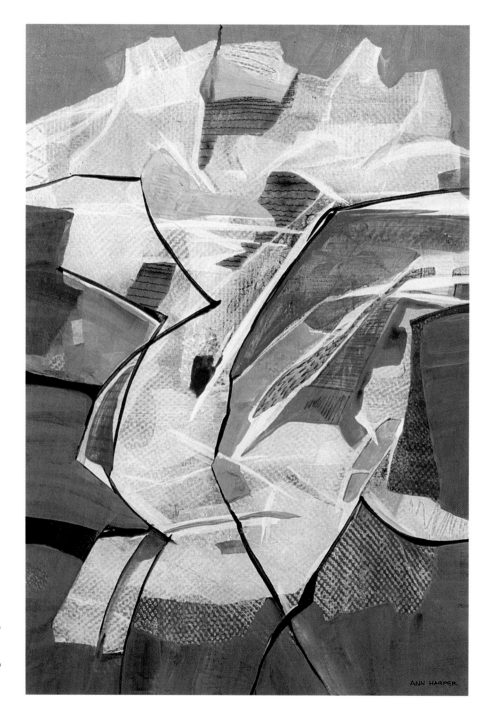

Ann R. Harper

Breaking Ice

watermedia on paper, 22" x 15"

74

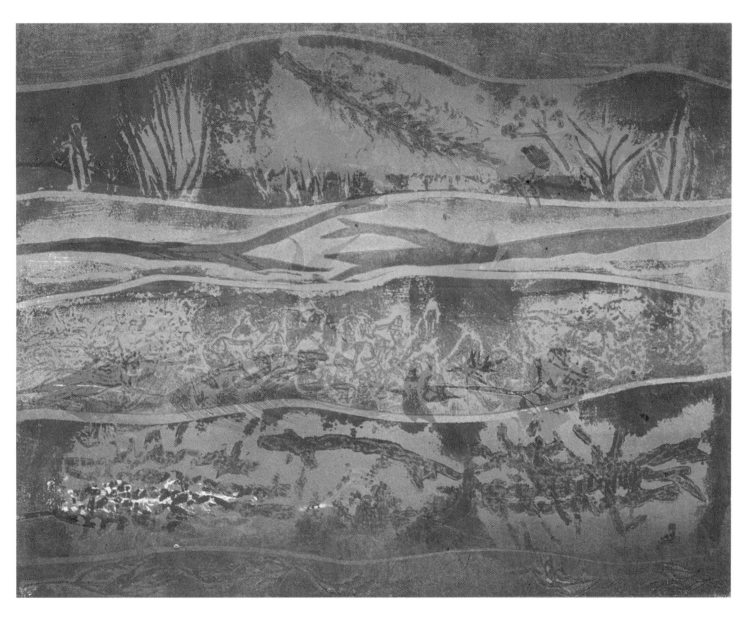

Janet Mustin

Earth Drifts, II

monotype, 18" x 21"

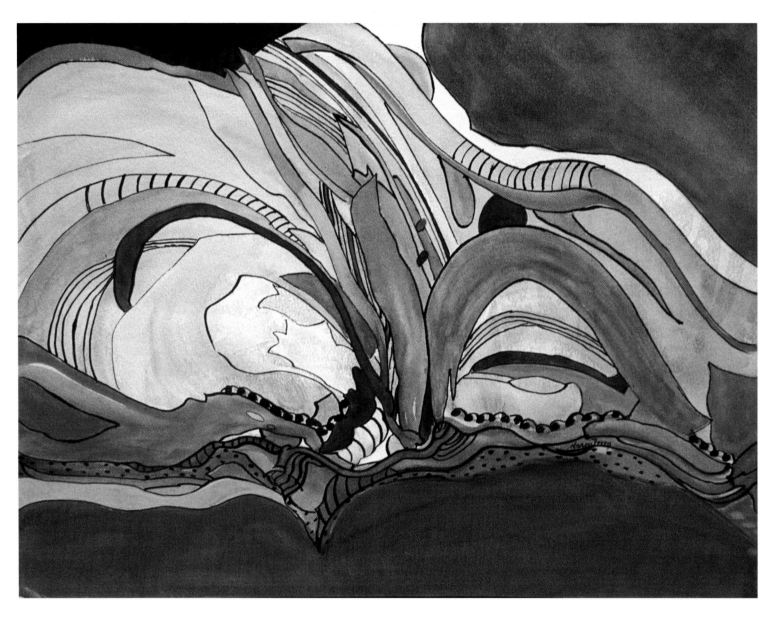

Nancy Perry

Mask

watercolor, acrylic and ink on watercolor board, 10.5" x 14"

THE HUMAN JOURNEY

searching *for* essentials

UNEXPECTED PATHS

awakenings

HONORING OTHER DOORWAYS

Vision Quests

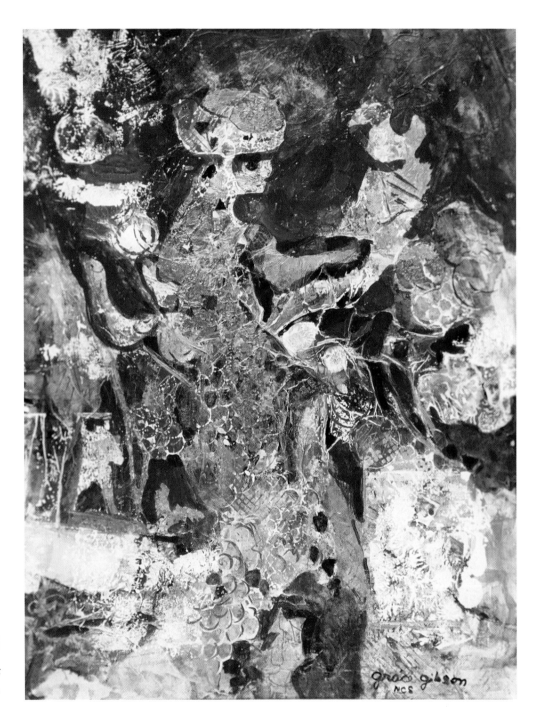

Betty Gráce Gibson

The Lady and Her Birds
mixed media collage, 21" x 17"

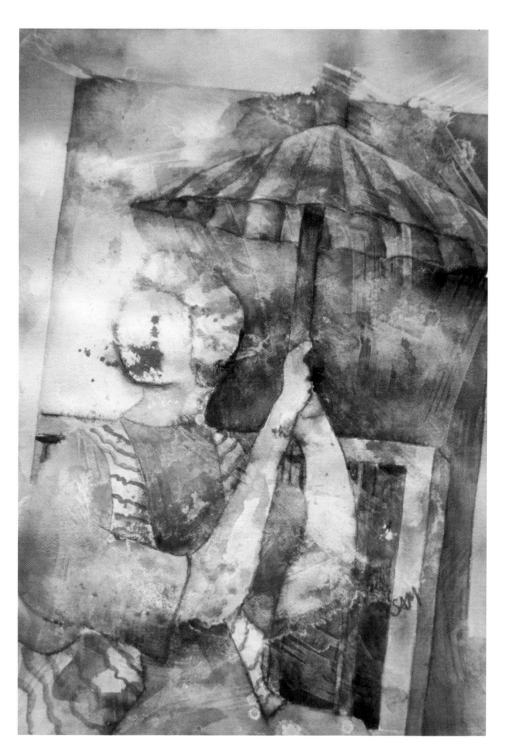

Sue Ann Mika

Red Parasol
watercolor, 20" x 14"

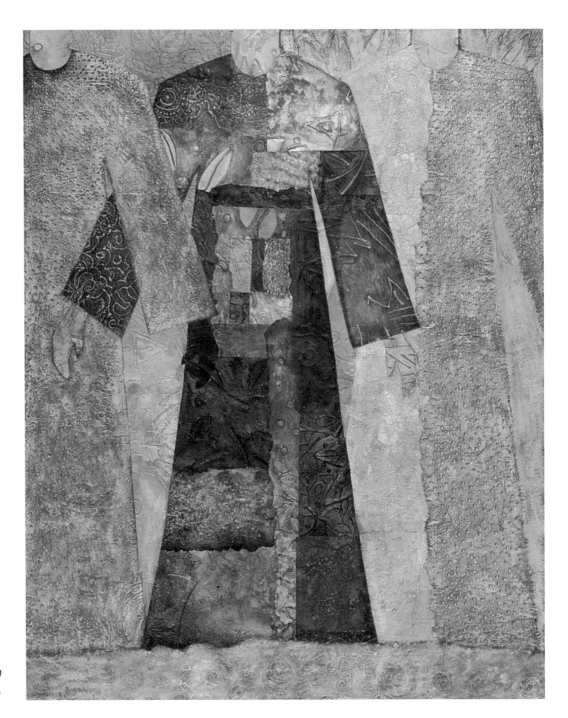

Priscilla Robinson

The Procession

handmade paper, 60" x 48"

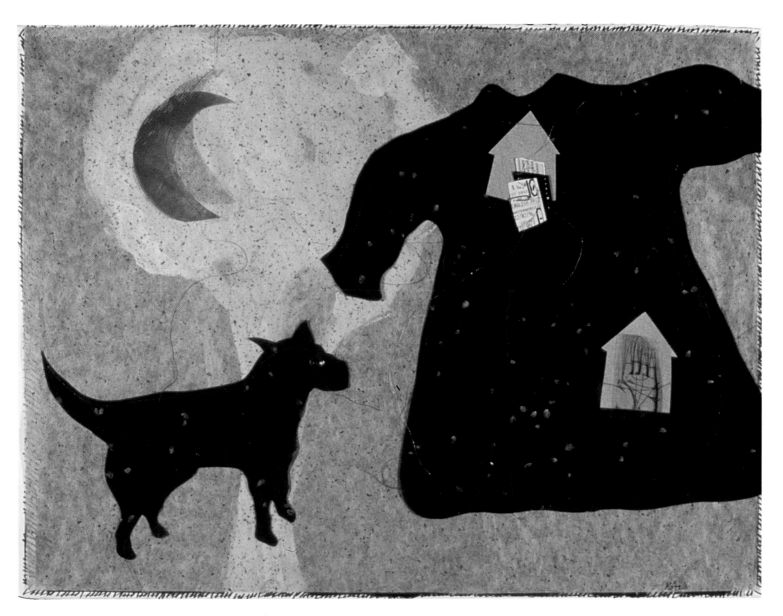

Elaine Wallace Morris

Black Dog Dress

mixed media, 22" x 30"

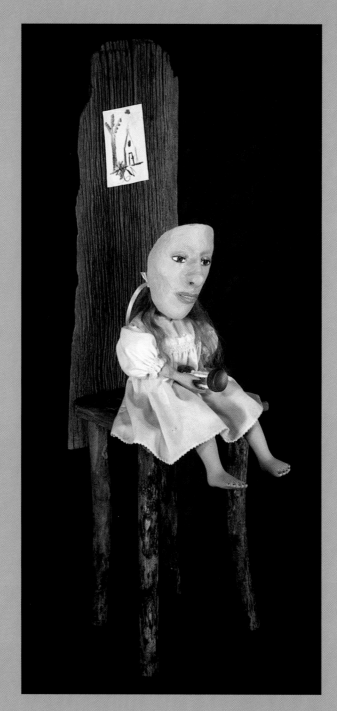

Selene Marsteiner

Millennium Child

assemblage, (wood, cotton, plastic,
plaster, paper, hair), 46" x 12" x 16"

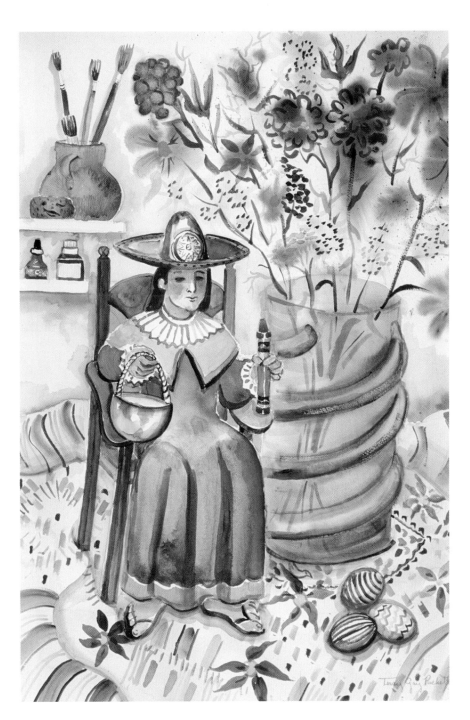

Terry Gay Puckett

Santo Niño with Red Crayola
watercolor on paper, 30" x 22"

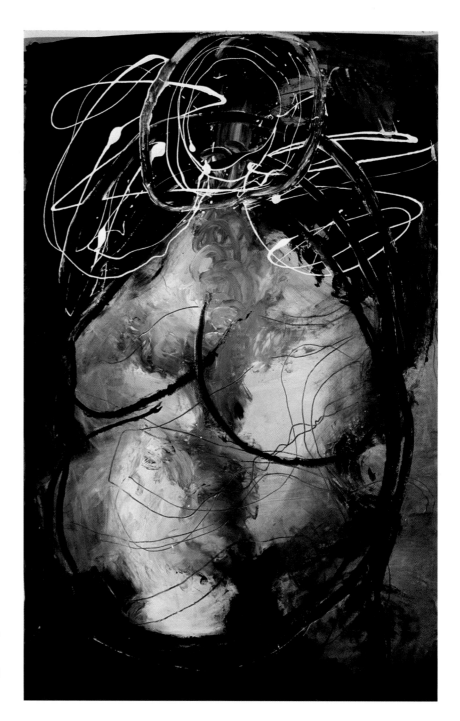

Diane Gibson Faissler

Gravid Virgin

acrylic, oil stick, graphite, 40" x 26"

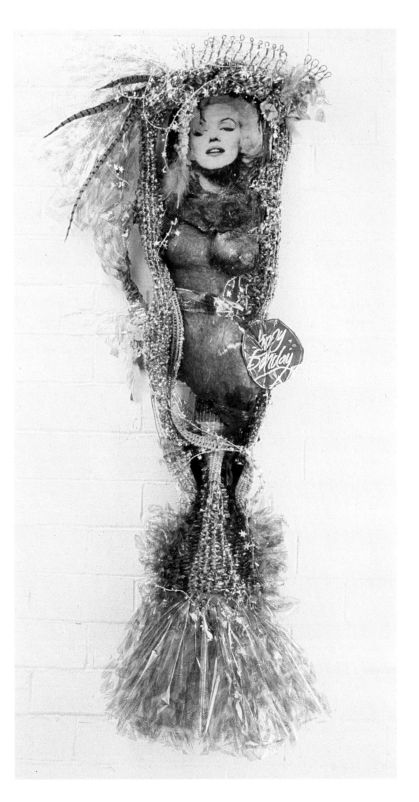

Frances Dezzany

Happy Birthday, Mr. President

mixed media assemblage (paper, wire, cellophane, mylar, feathers, plastic, jute, hanger),
72" x 30" x 9"

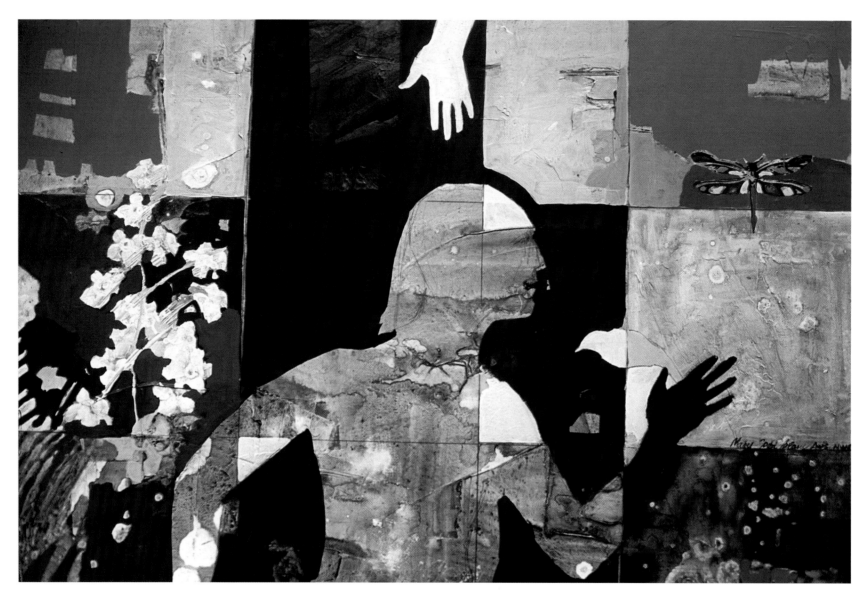

Mary Todd Beam

A Muse for New Beginnings
watermedia, 30" x 40"

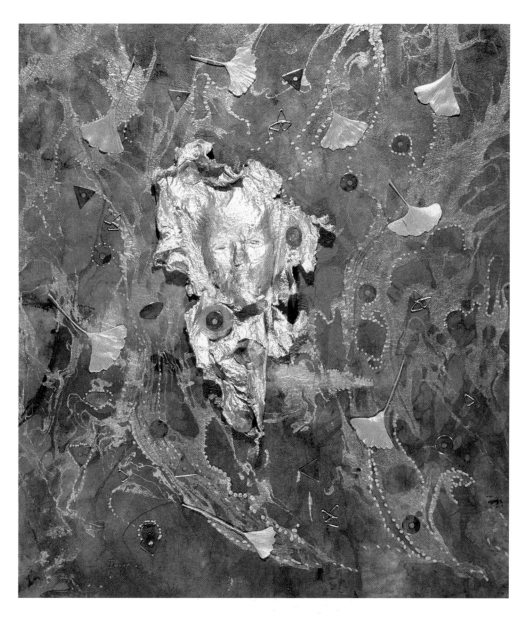

Dorothea M. Bluck

Spiritual Journey
hmp, mixed media, 24" x 22"

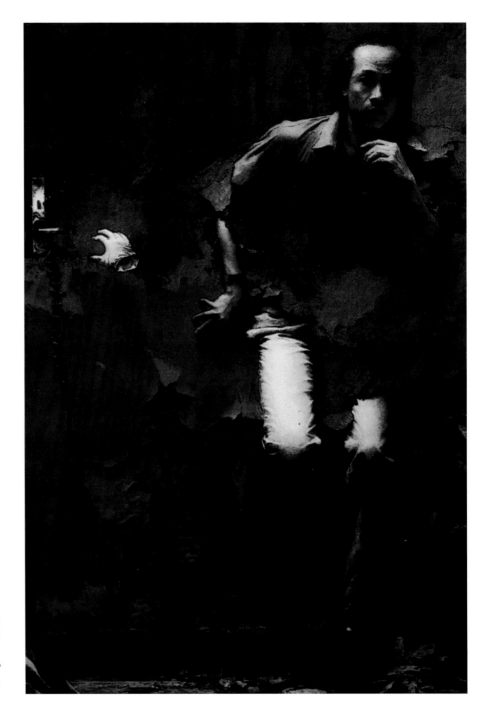

Victoria Lord

Escape Through the Layers of Life
watermedia collage on canvas, 40" x 30"

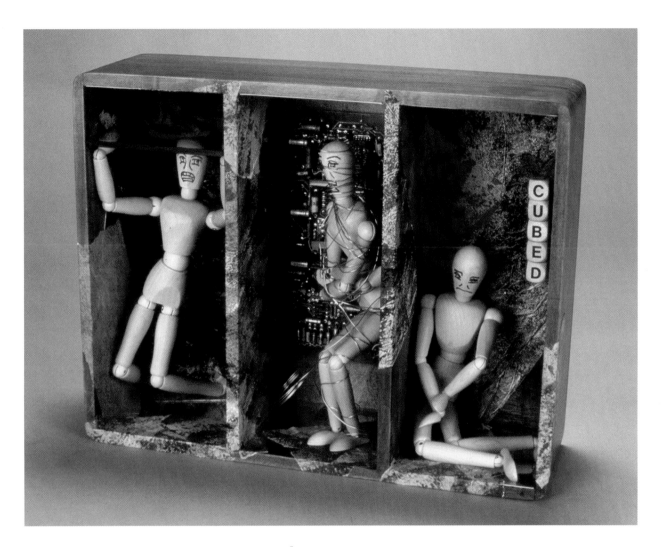

Carolyn Hansen

Trapped, Wired and Cubed

assemblage, 11" x 13" x 9"

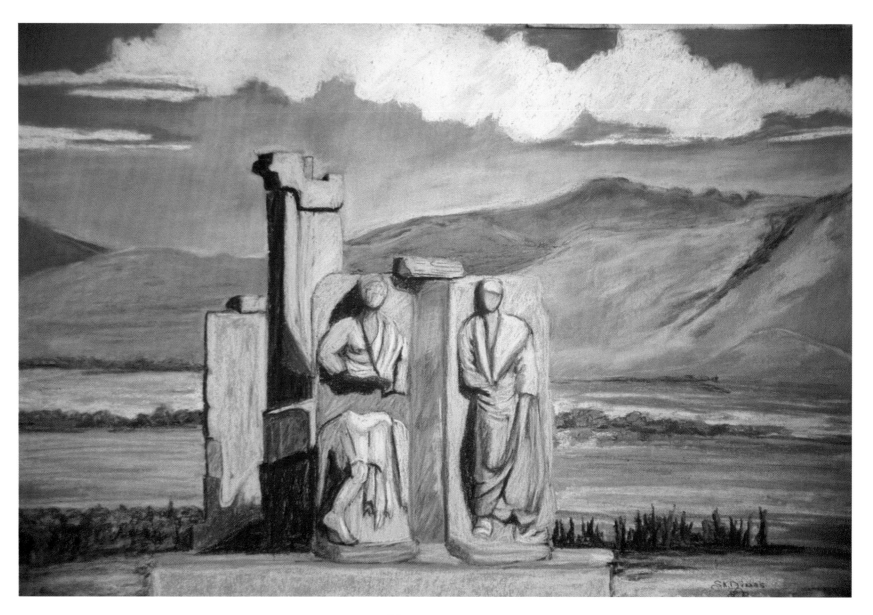

Sally Dimas

Treasures of Greece

pastel, 18.75" x 23"

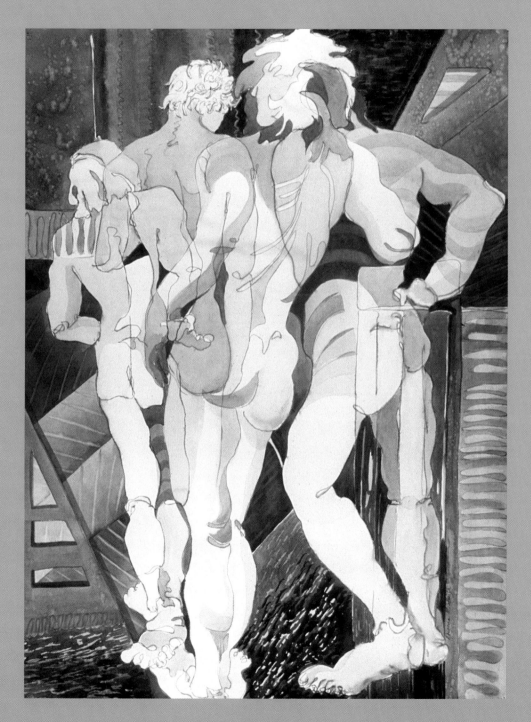

Rowena M. Smith

The Gathering

watercolor, 36" x 28"

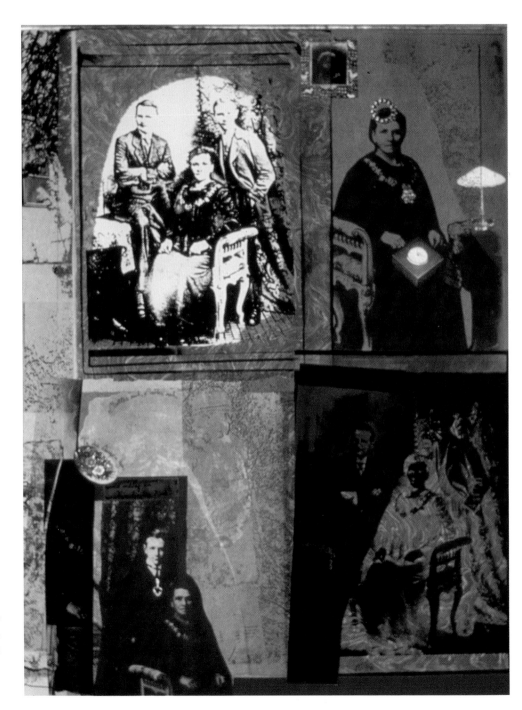

Marlene Zander Gutierrez

Immigrant Series:
Mutter, schlaf im Himlishcher Ruh
(Mother, Sleep in Heavenly Peace)

mixed media (photos on film,
serigraphy, collage) 26" x 20"

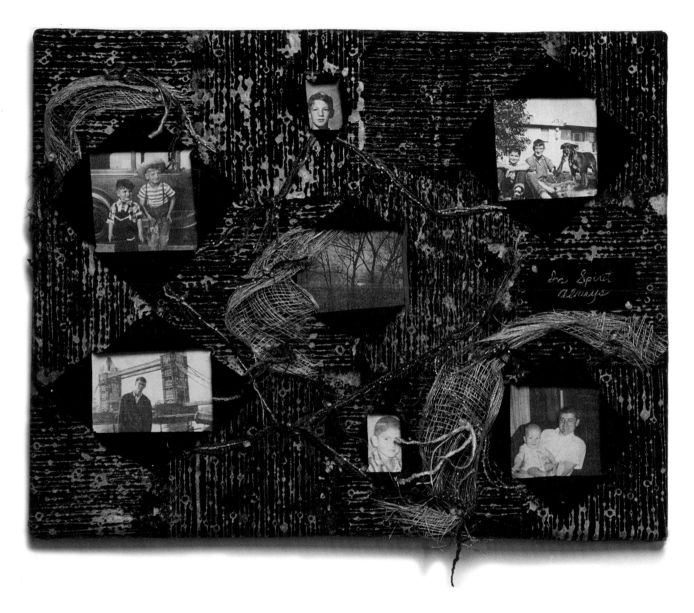

Betty E. Rice

Healing Memories

assemblage (cloth, photo transfer, stitchery), 14" x 18"

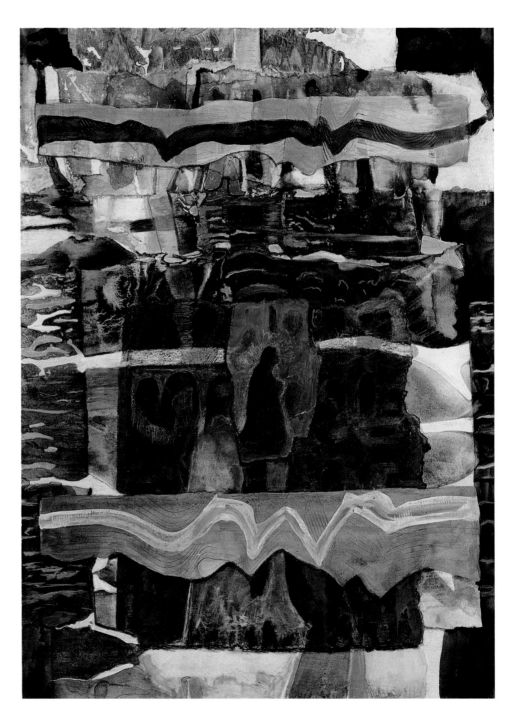

Marilyn Gross

Meditation

mixed media (acrylic wash, gesso,
watercolor, caran d'ache), 30" x 22"

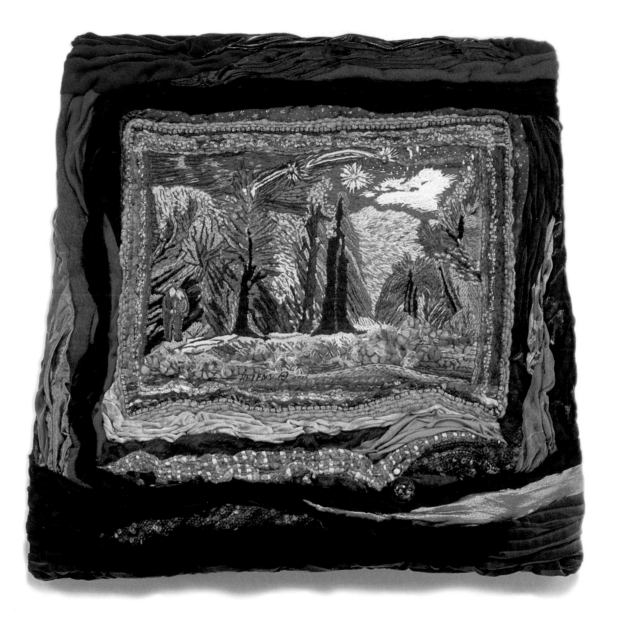

Helenn Rumpel

Forest
stitchery and fiber, 22" x 24" x 2"

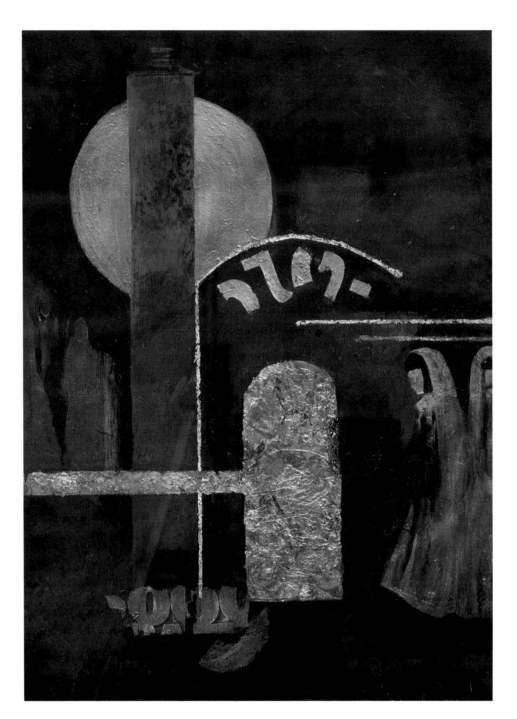

Waneta Swank

Door to Expectations
collage, 22" x 16"

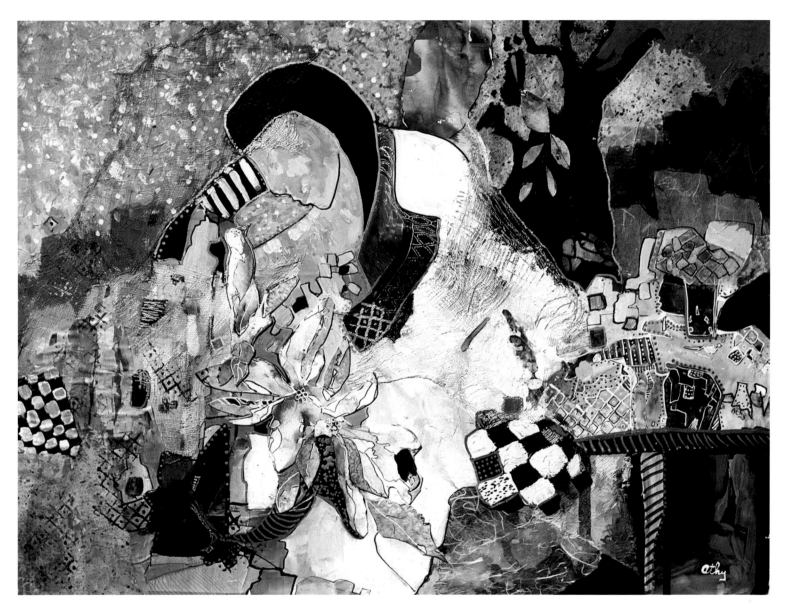

Phyllis Athy

Seeing Backwards

acrylics, 30" x 40"

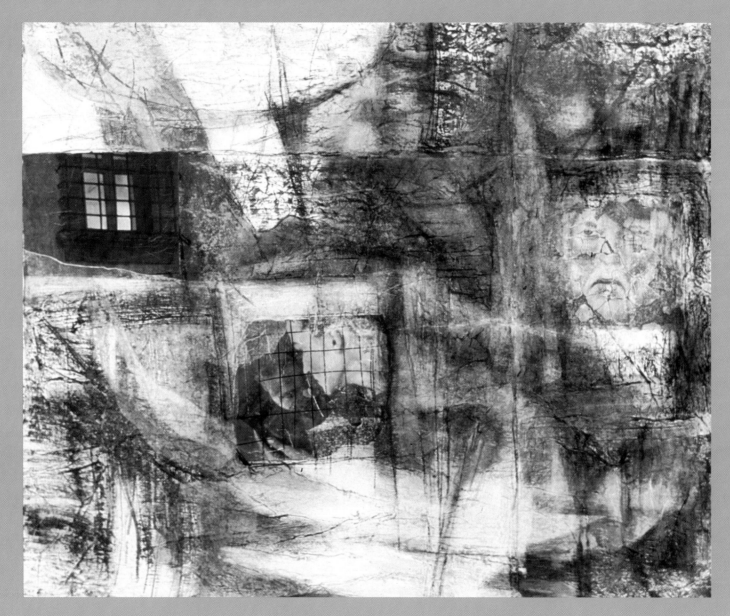

Anne Winston Brown

Past Hopes and Dreams
mixed media on paper, 29" x 35"

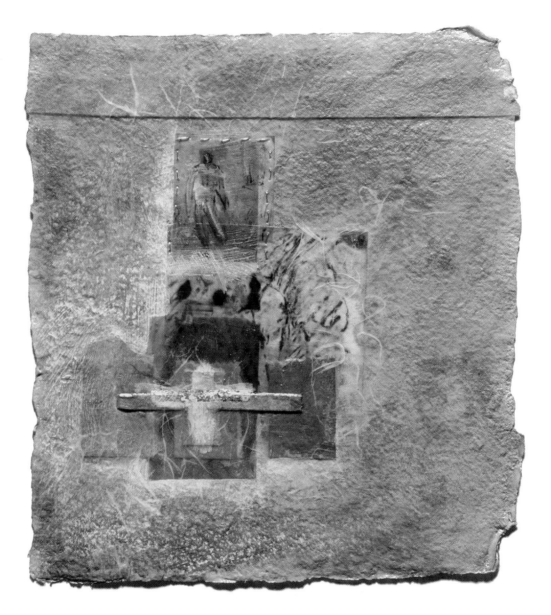

Carol Small

Earth Sounds II

mixed media, 8" x 7"

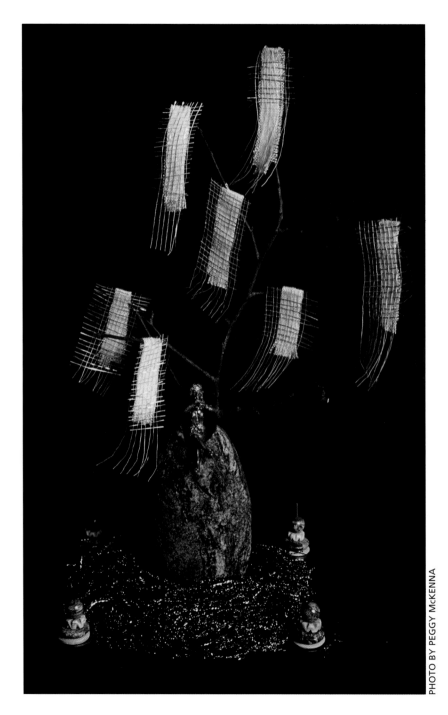

Diane Brott Courant

Sittin' On Top of the World

assemblage with fiber, 14" x 7" x 5.5"

Betty Keisel

Path of Light

giclé print, 13.5" x 18"

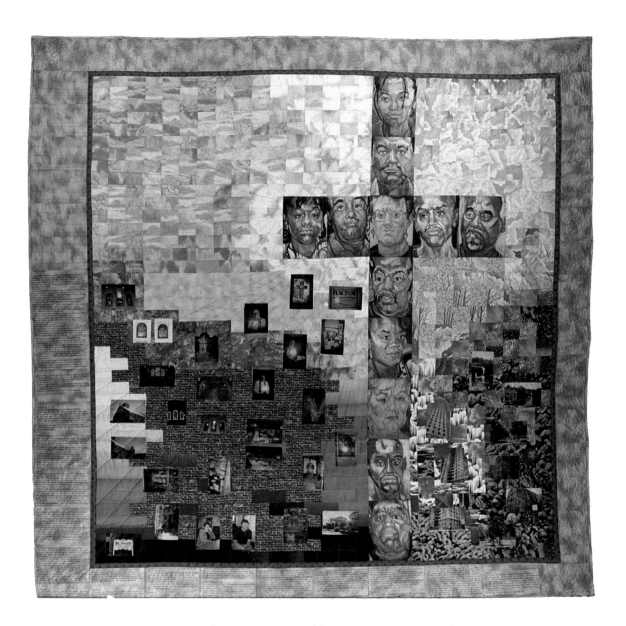

Wilma Bulkin Siegel

Homeless Quilt

cotton, 92" x 92"

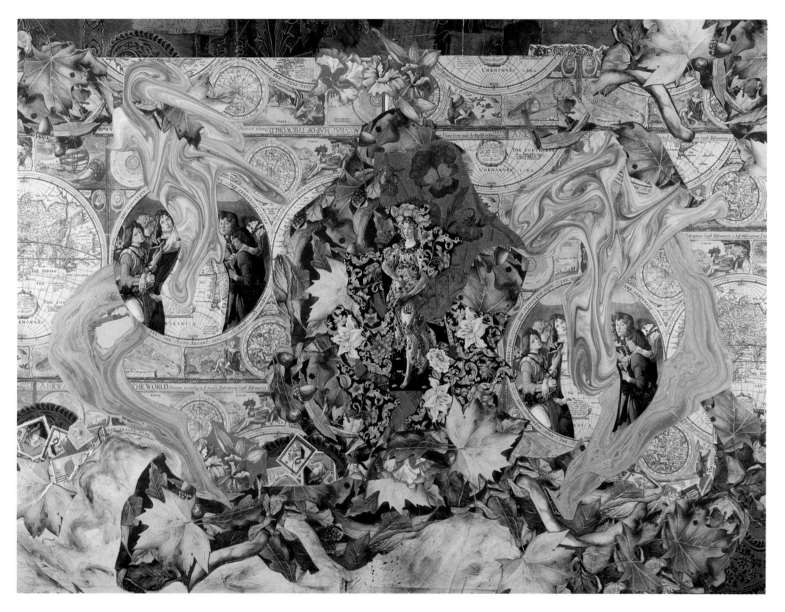

Carol Perroni

Journal of Forgotten Memories

mixed media, 35" x 44"

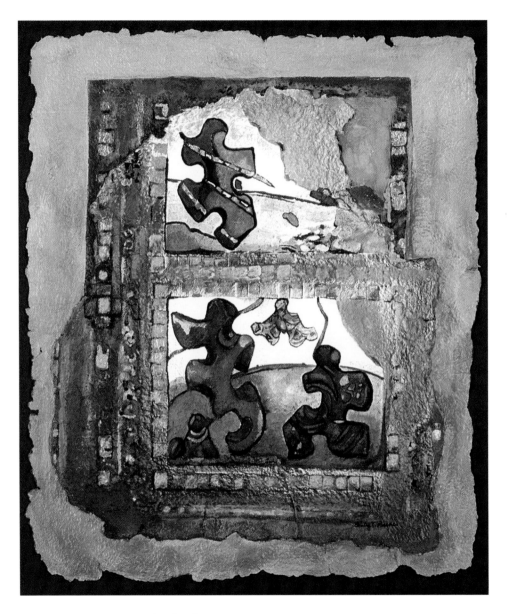

Shirley C. Barnes

Last Entry

mixed media collage on handmade paper, 29" x 23"

TRACES/MARKINGS

STRANDS *of* LIFE

ANCIENT ALPHABETS

gathered impressions

INTERTWINING TIME AND MEMORY

Endless Possibilities

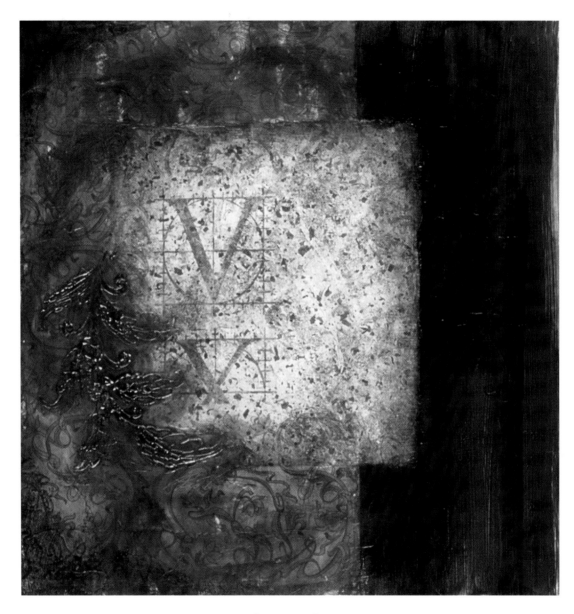

Leslie Ebert

Depths of Love

mixed media (encaustic with acrylic mediums), 12" x 12" x 1"

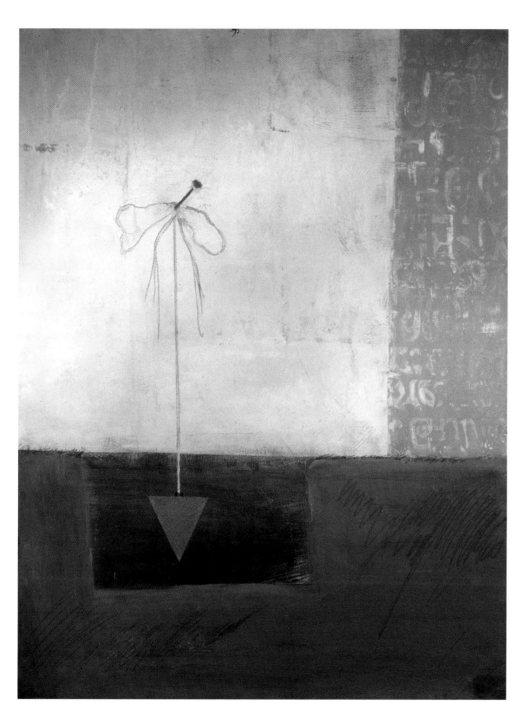

Delda Skinner

Line and Plummet
acrylic/casein, 30" x 22"

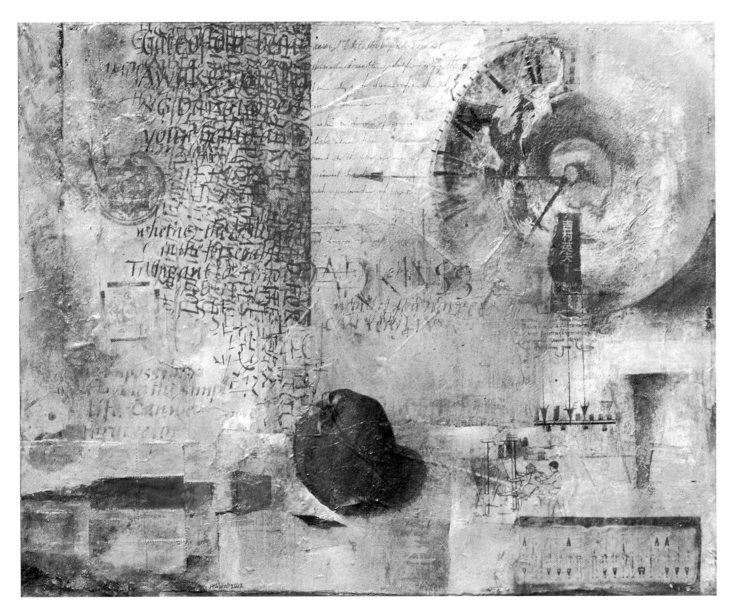

Nadia Hlibka

Ripe for the Picking

mixed media gel transfer, 15" x 18"

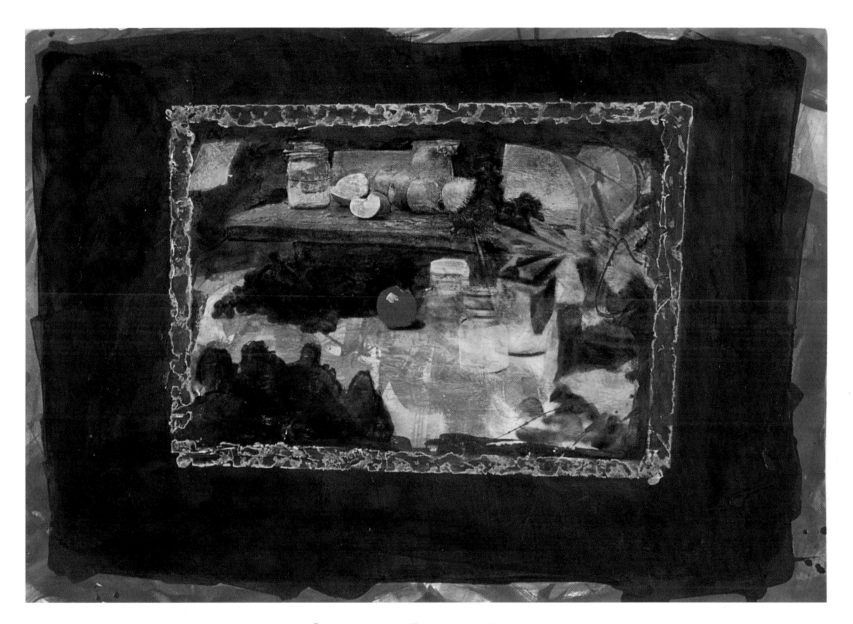

Dianna Cates Dunn

Red

acrylic collage, 17" x 25"

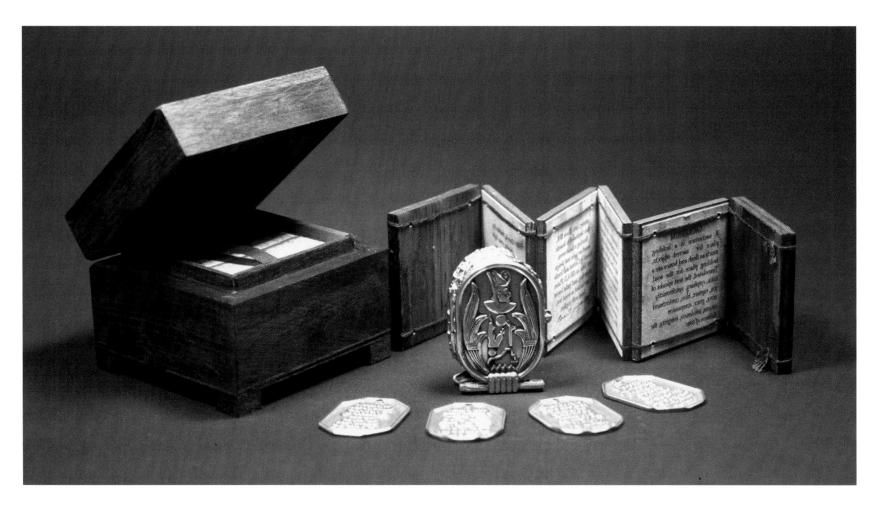

Mary Crest

Sacrarium, Artist Book

plates, silver box, palm leaf, suede-lined box, 2.25" x 3" x 3

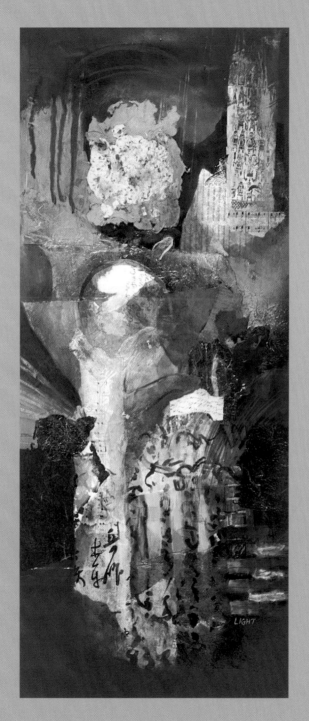

Marta Light

Markham Melody
mixed media, 38" x 22"

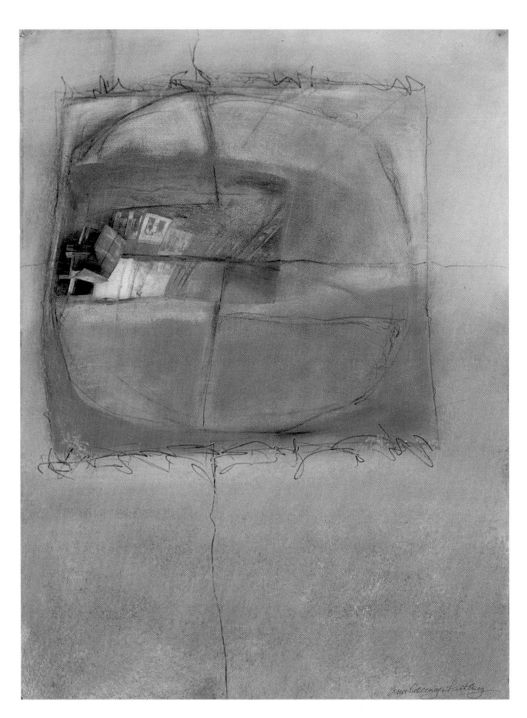

Ann Bellinger Hartley

Homestead

alkyd on paper, photo transfer, 30" x 22"

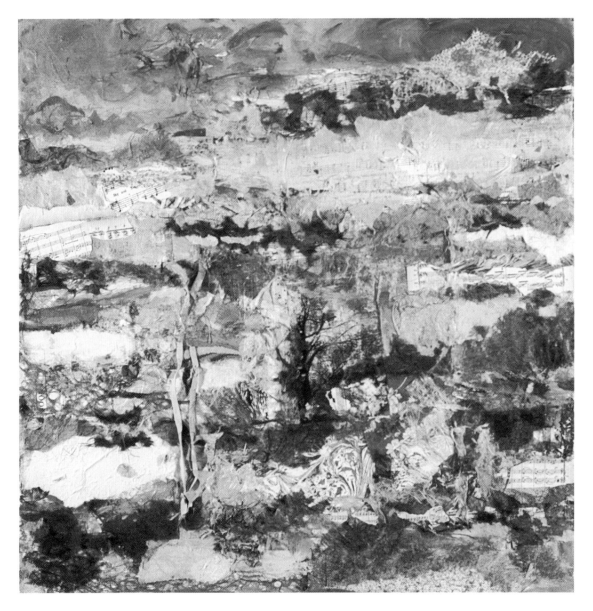

Alice Harrison

Sky and Mountains

acrylic, mixed media collage, 24" x 24"

Doris Steider

High Lonesome

egg tempera, 18" x 24"

Eydi Lampasona

Underway
acrylic collage, oil pastel, 30" x 24"

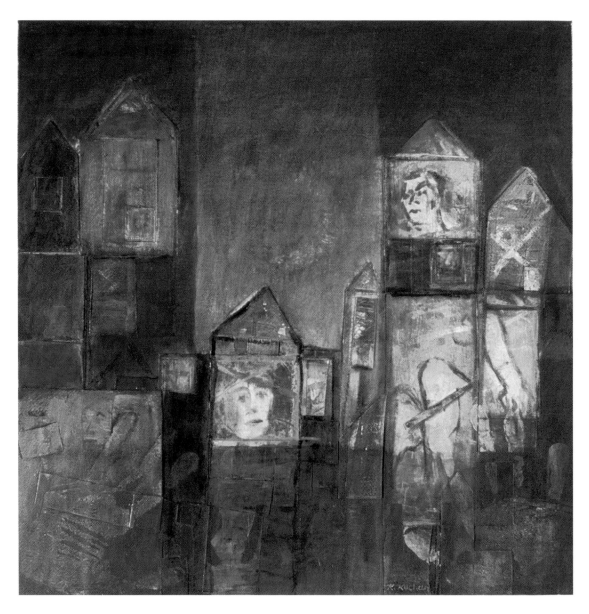

Kathleen Kuchar

Behind Closed Doors

acrylic collage, 18" x 18"

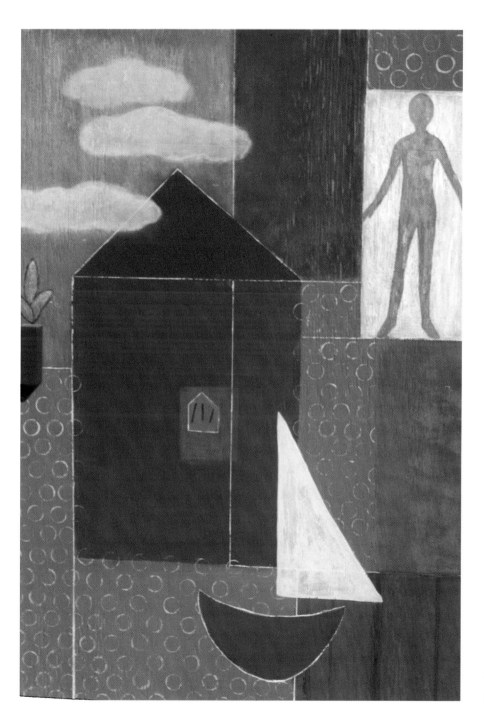

Mary Hunter

Inner House
mixed media on wood, 48" x 40"

Veronica Morgan

12 over 8: Historic House Series

stabilized cotton relief, 51" x 33" x 3"

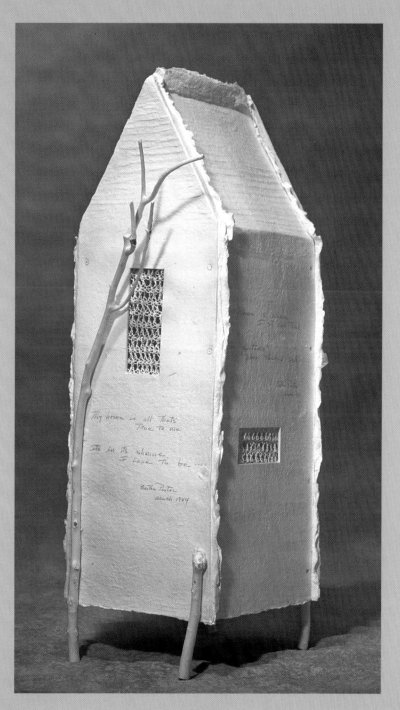

Karen White

Grandma's House
mixed media, 26" x 8.5" x 5"

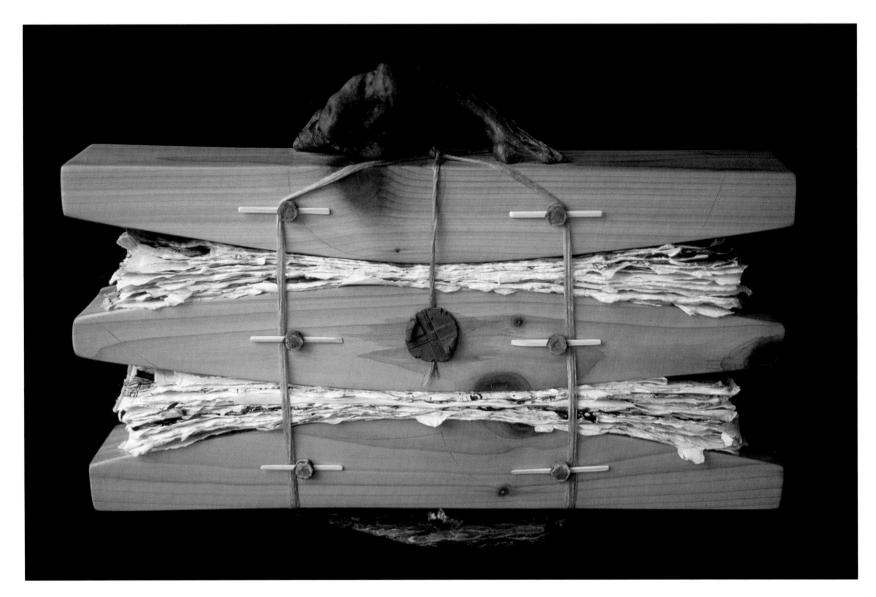

David Stoddard

Book of the Gods

mixed media (paper, cedar, copper, sinew, ink), 15" x 22"

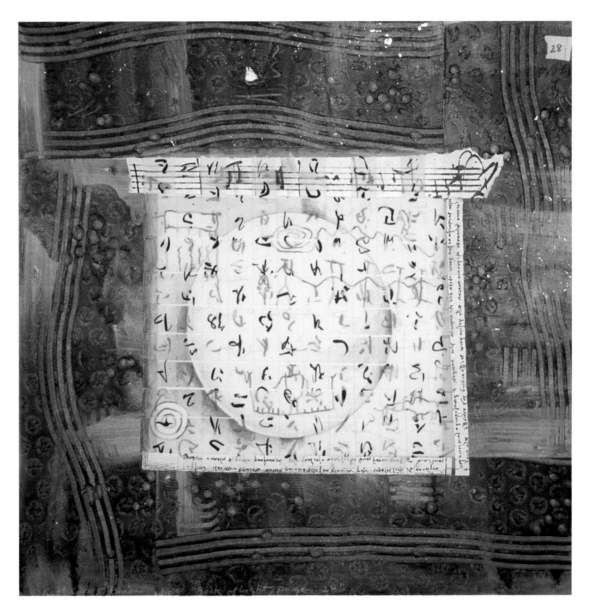

Kathleen O'Brien

Book of Light, Page 28

collage, 11" x 11"

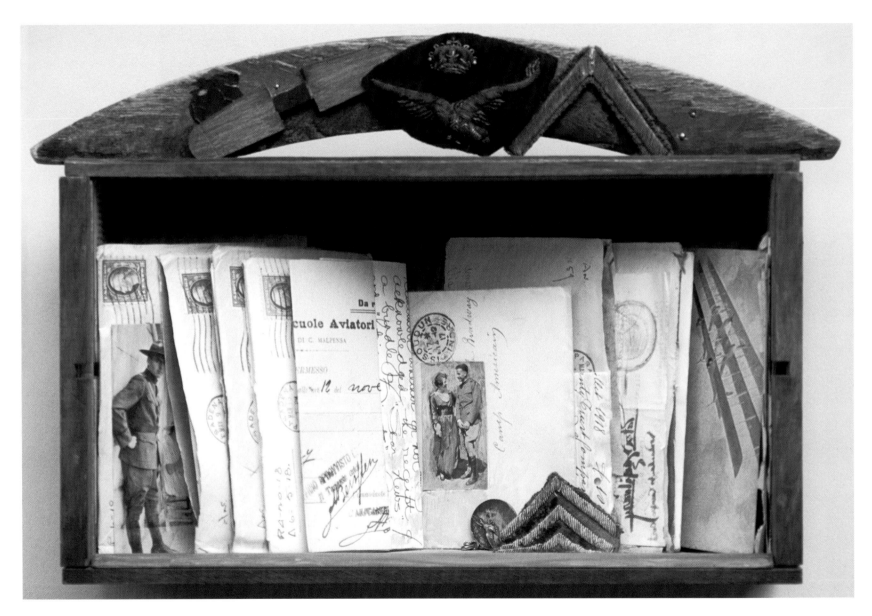

Pat Cox

War Correspondence

mixed media assemblage, 9.75" x 19.25"x 4.5"

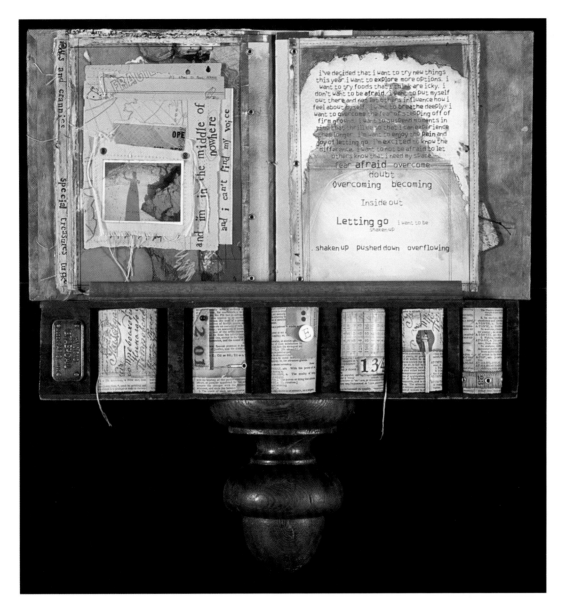

Anne Morgan

Tucked In, Pressed Down and Overflowing Book

assemblage, 16" x 17"

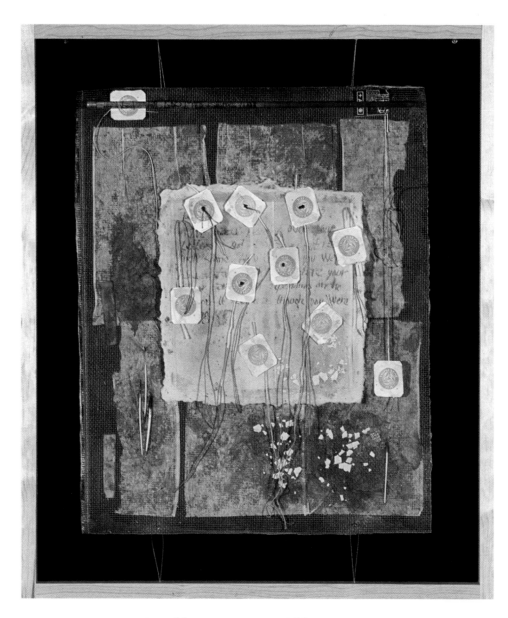

Sally A. Williams

T. B. Papers

mixed media, 18" x 15"

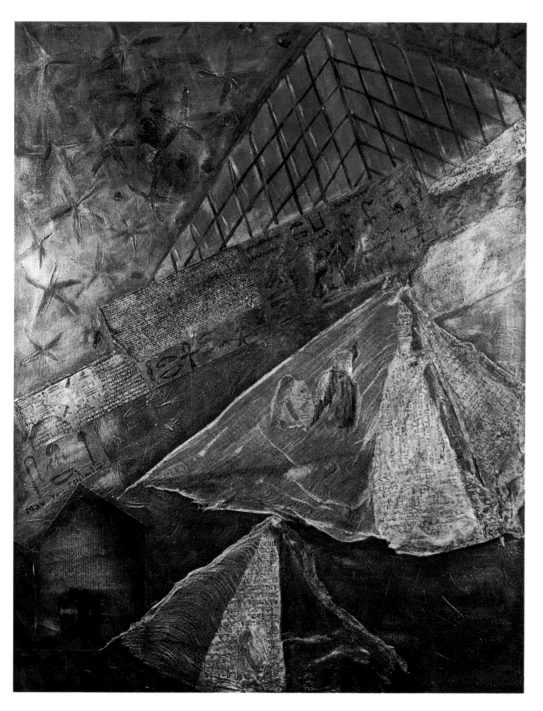

Jaleh A. Etemad

May You Illumine, Now and Then
mixed media on canvas, 48" x 37.5"

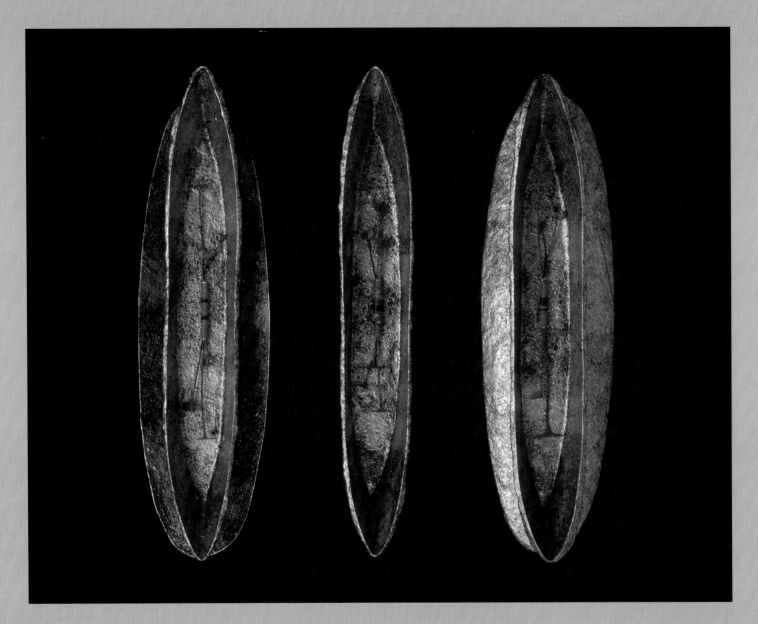

Nancy Young

Three Pods

mixed media, 24" x 30" x 5"

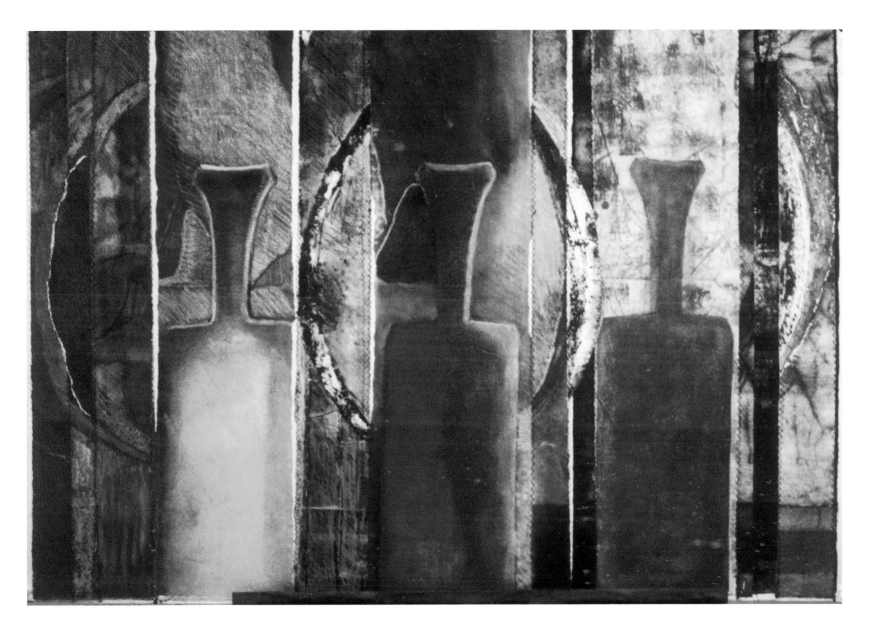

Elaine Insero

The Three Gifts
collaged monoprint, 30" x 36"

Ara (Barbara) Leites

Setting Up
acrylic on paper, 22" x 30"

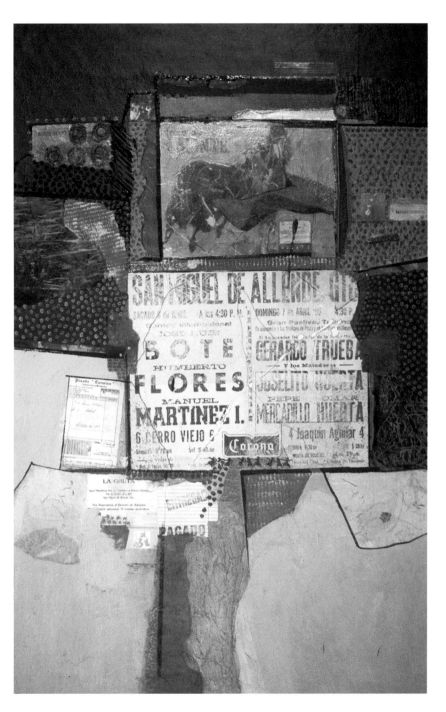

Valaida D'Alessio

Memories of San Miguel

mixed media collage, 48" x 24"

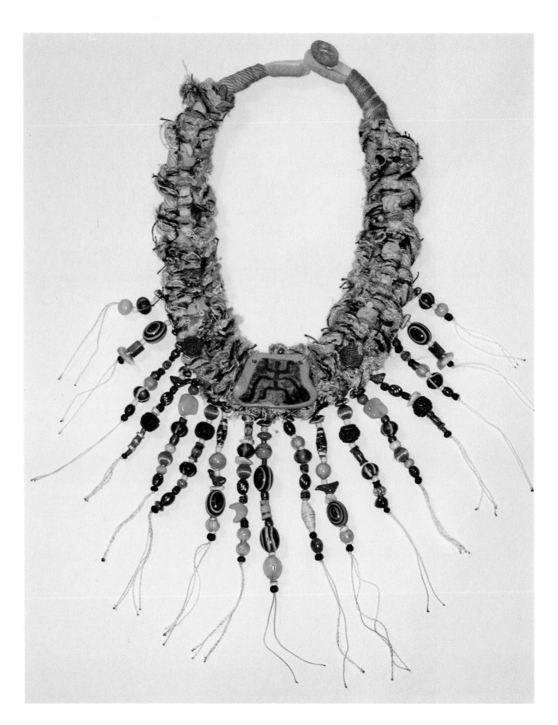

Allyson Rickard

Shaman Woman
mixed media necklace, 24"

Gini Walters Goldi

Zen Sanctuary

collage, 7" x 5"

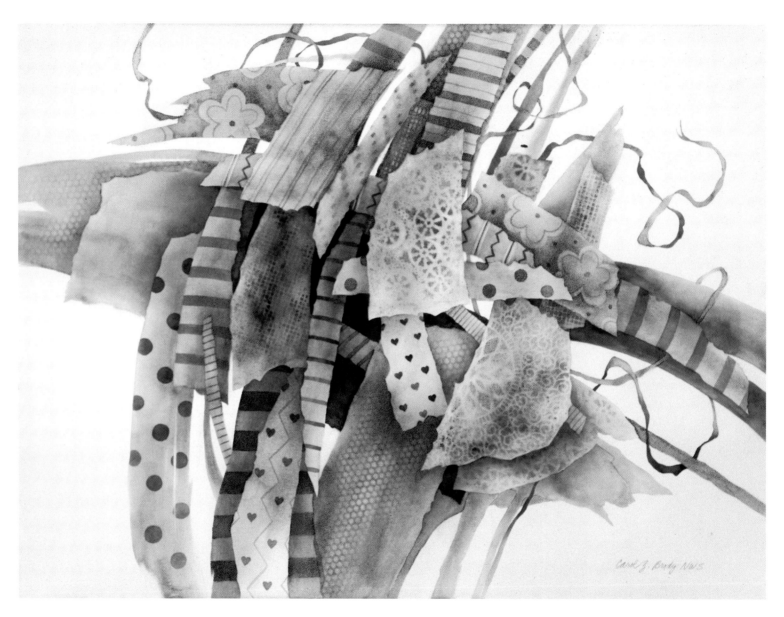

Carol Z. Brody

Party Papers and Ribbons IV
watercolor, 22" x 30"

Hanne-Lore Nepote

Spring Dreams II
watercolor, 11"x 8.5"

Roseanne Hudson

Certainty

mixed media, 22" x 15"

Stephanie Nadolski

Maya—Ix Chel

mixed media, 16" x 20"

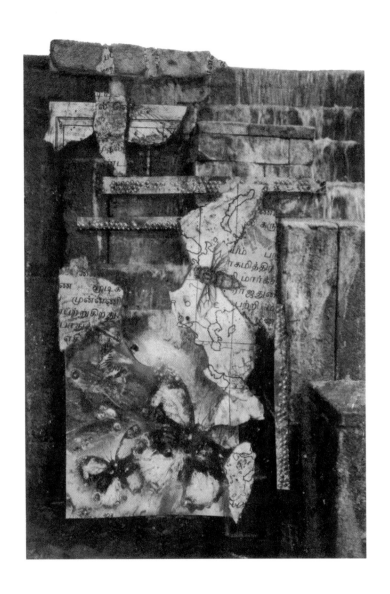

Dawn McIntyre

Wailing Wall

collage (photo transfer, ink, acrylic on paper), 5.5" x 4"

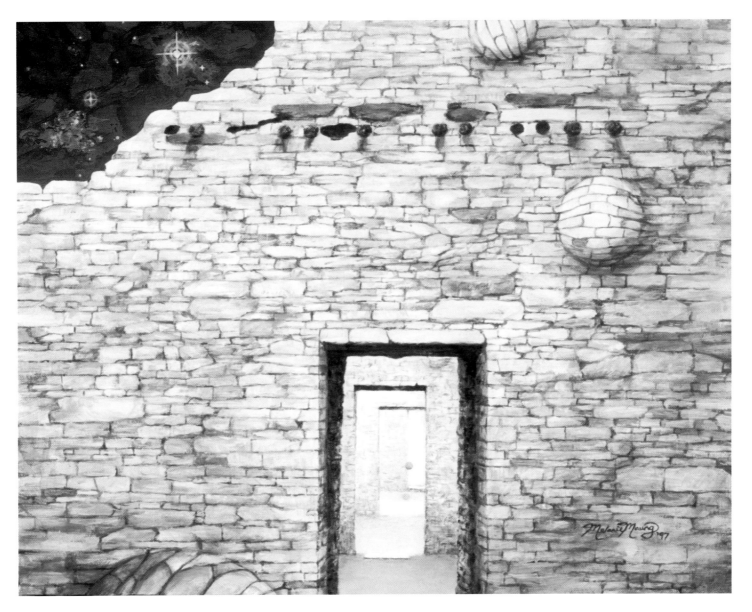

Melanie Maung

The Return

acrylic, 11" x 14"

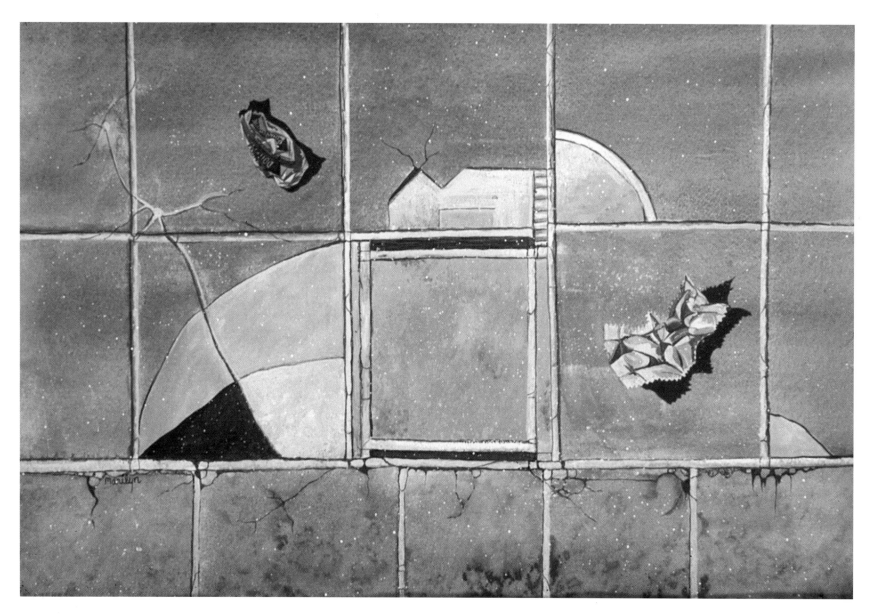

Marilyn G. Stocker

Sunday Afternoon at the Rialto

watermedia, 15" x 23"

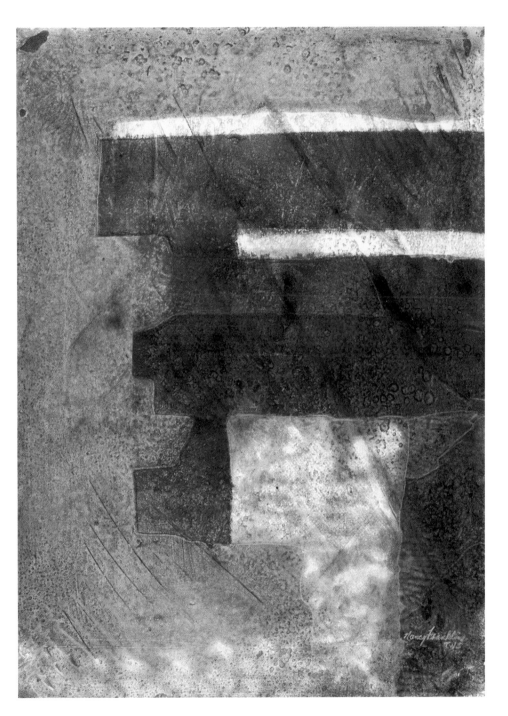

Nancy Franklin

Harmonic
watermedia, 36" x 28"

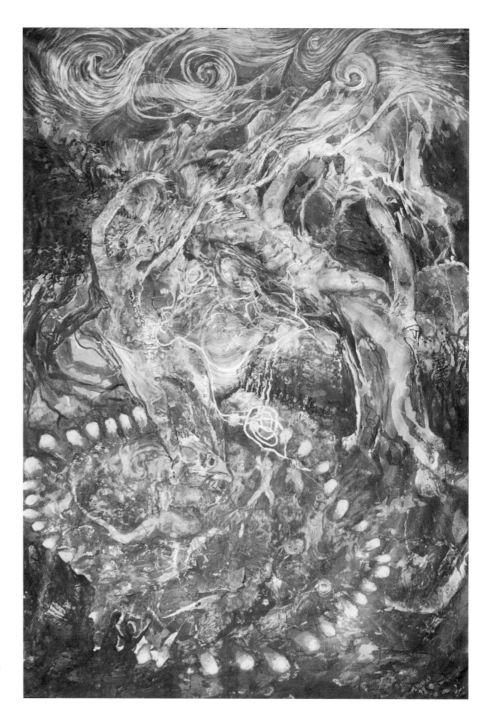

Mary F. Hughes

Journey
oil and acrylic, 72" x 48"

TRANSFORMATIONS

EXPERIENCES *of* SPIRIT

METAMORPHOSES

webs of healing

TOUCHING THE SOURCE

Celebrations

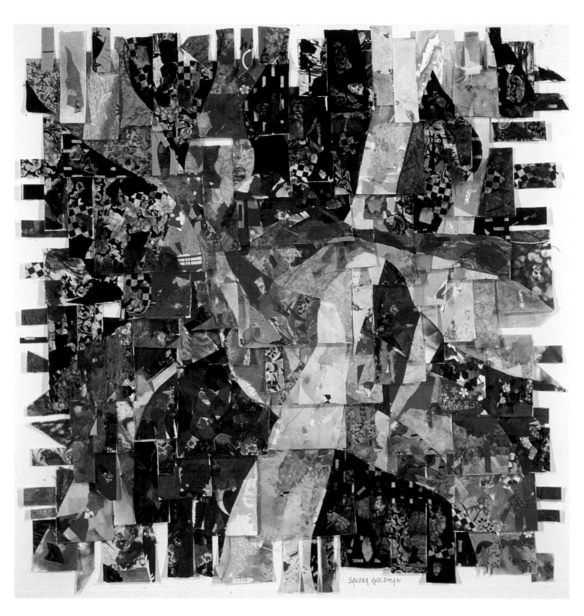

Sandra Goldman

Arabesque

watercolor collage, 36" x 36"

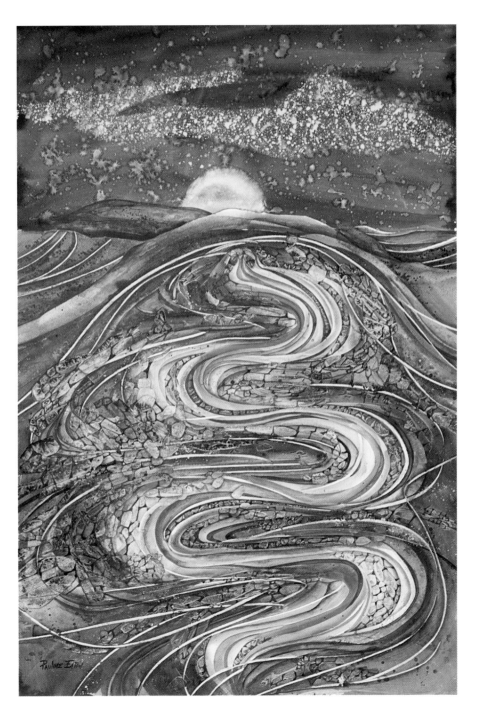

Pauline Eaton

Serpent Energies

watercolor, 30" x 20"

143

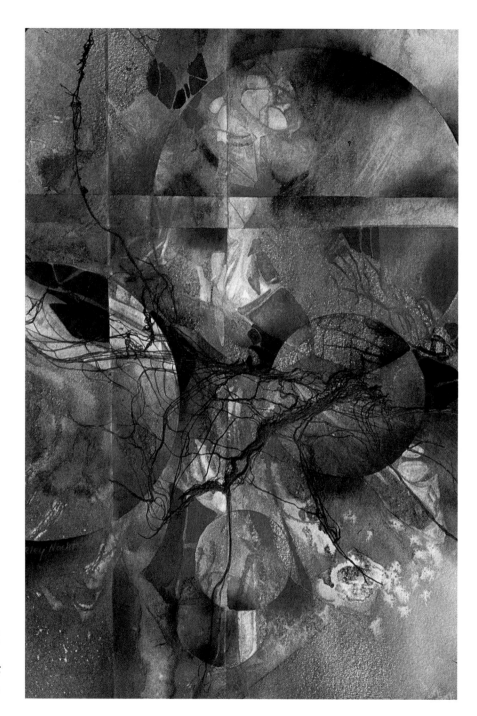

Shirley E. Nachtrieb

Crystal Graphic Planes

mixed media, 15" x 11"

144

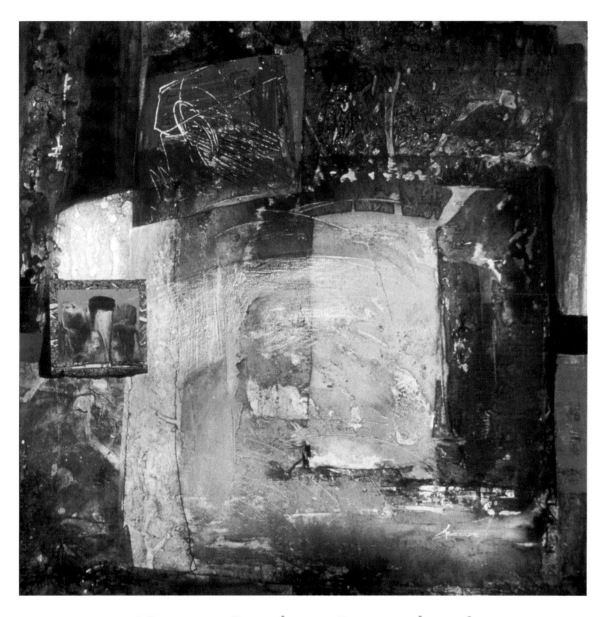

Karen Becker Benedetti

Ageless Glow

fluid acrylic collage, 30" x 30"

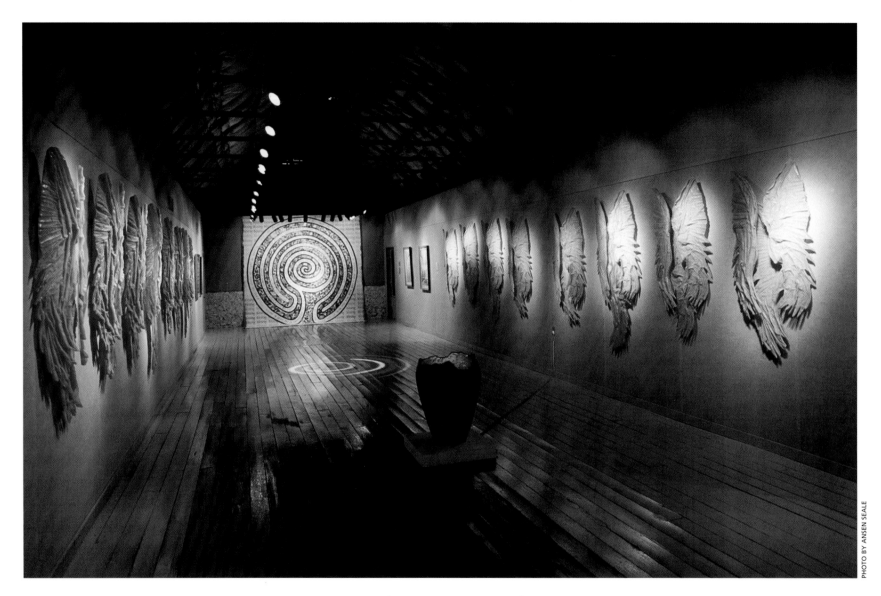

Juliet Wood

On the Wings of the Spirit, Blessing Journey

installation at the Center for Spirituality and the Arts, San Antonio, TX

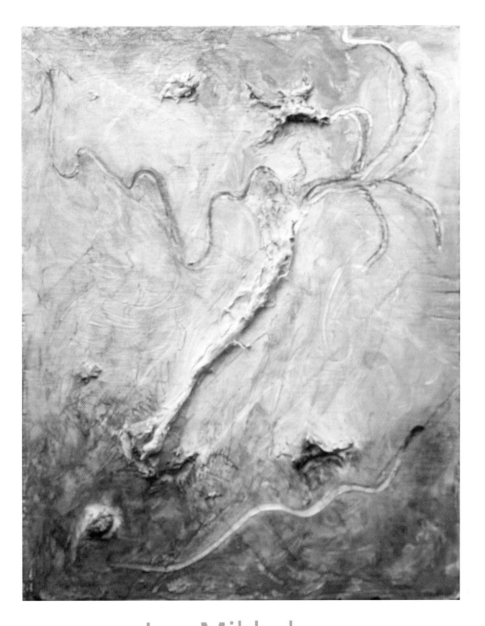

Jan Mikkelsen

Transforming Journey to the Southwest

tile collage, 12" x 9"

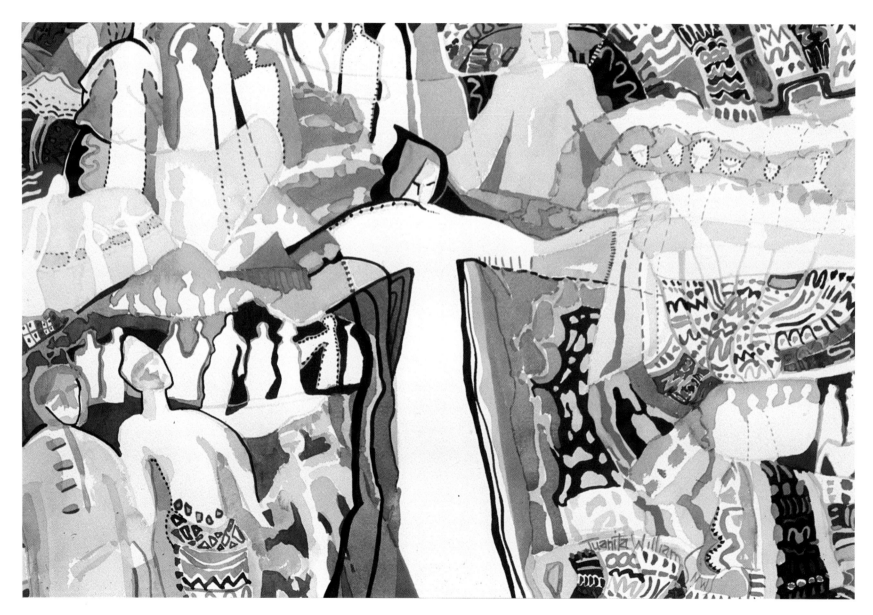

Juanita Williams

White Place Revisited
watercolor, 17" x 23"

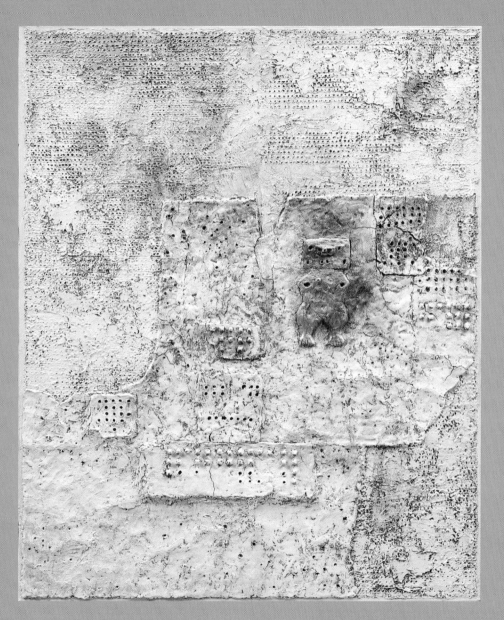

Virginia Dehn

Traces

acrylic, clay, 48" x 40"

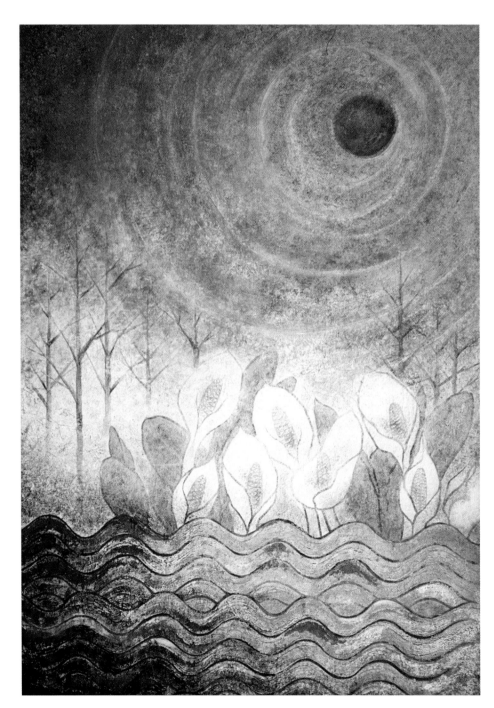

Iku K. Nagai

High Noon

mixed media, dry pigments with
silver leaf on panel, 37" x 28"

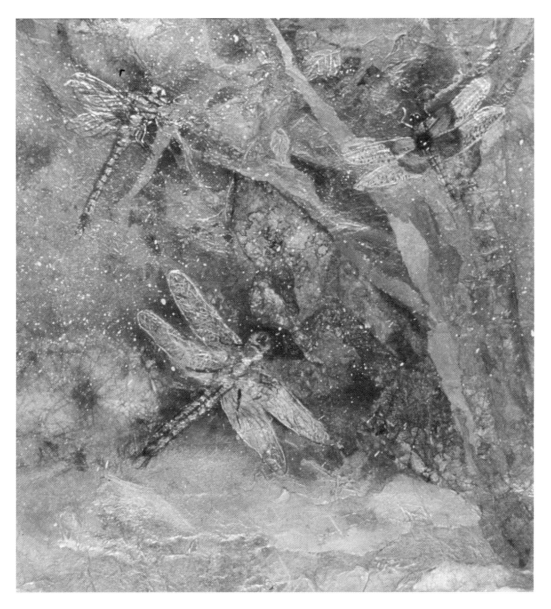

Shifra Stein

Enchanted Garden

gouache on Masa paper, 18" x 18"

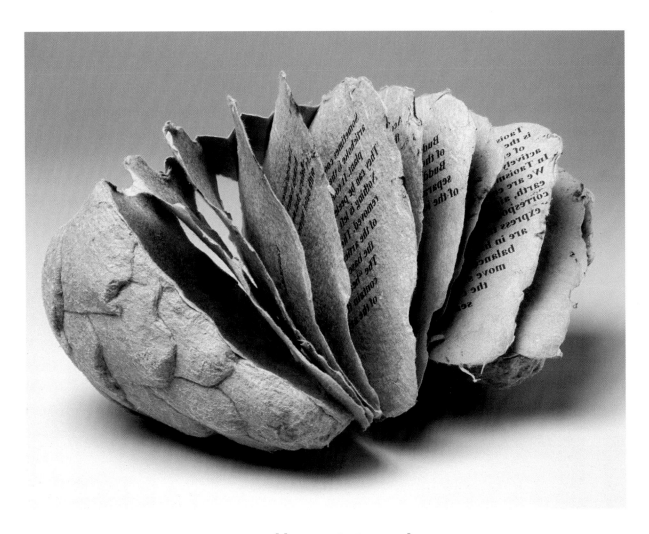

Mary Ellen Matthews

The Artichoke View of Human Nature

open book, 6" x 5" x 5"

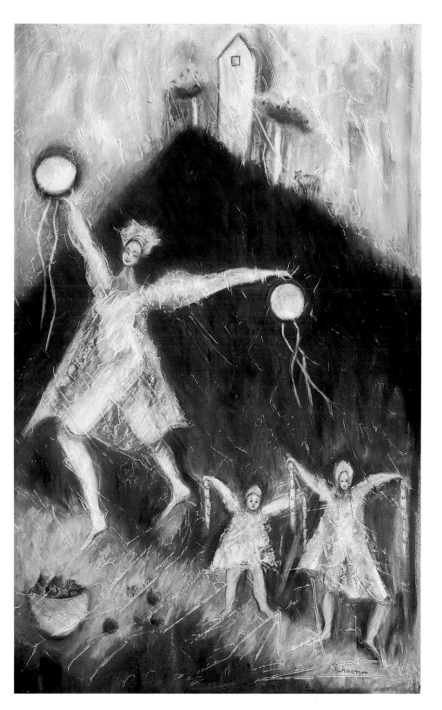

Jackie Schaefer

In The Garden I
pastel on gessoed board, 39" x 27"

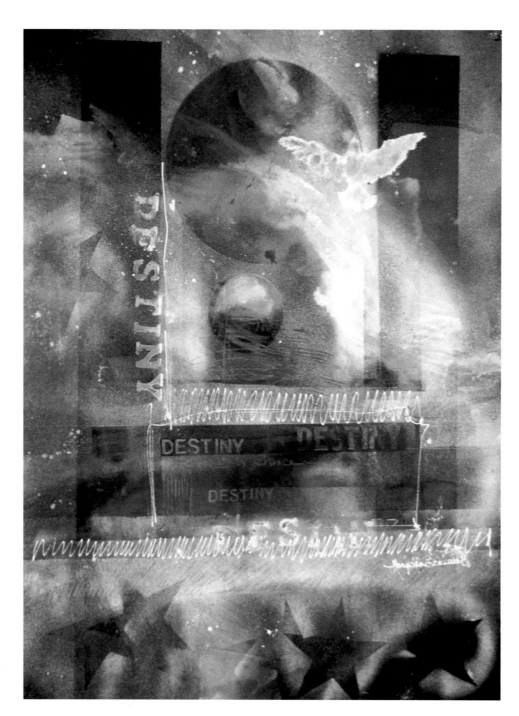

Mary Ann Beckwith

Origins: Destiny

watermedia, 30" x 22"

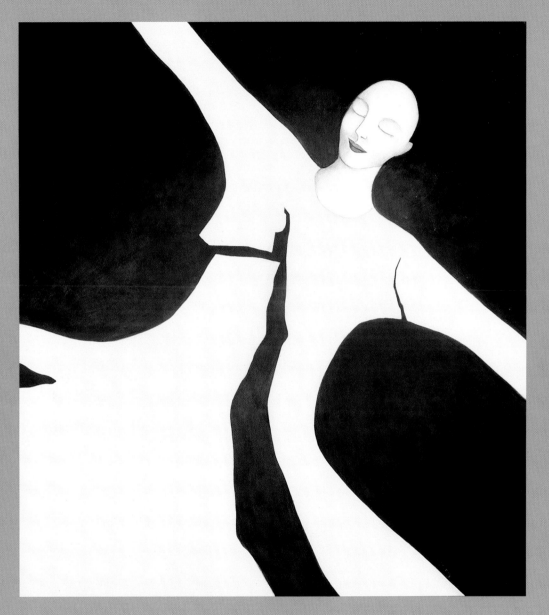

Mimi Chen Ting

Rapture

acrylic painting on canvas, 48" x 42"

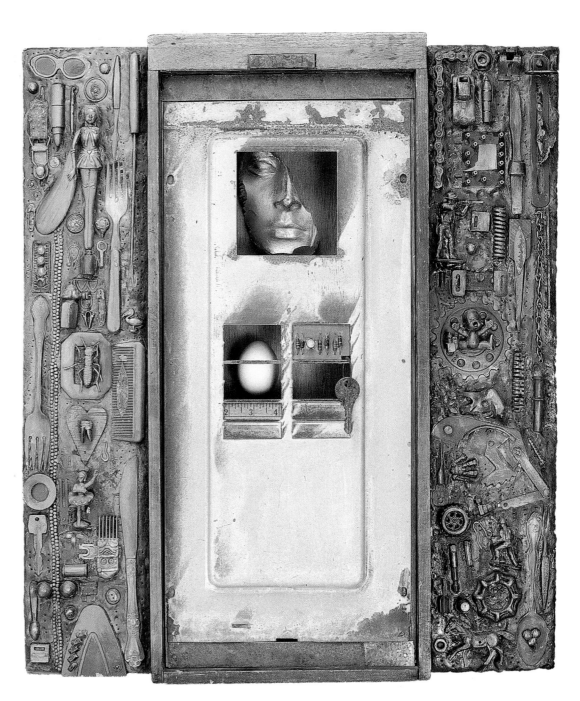

Annemarie
Rawlinson

Woman

mixed media, 25" x 22" x 4"

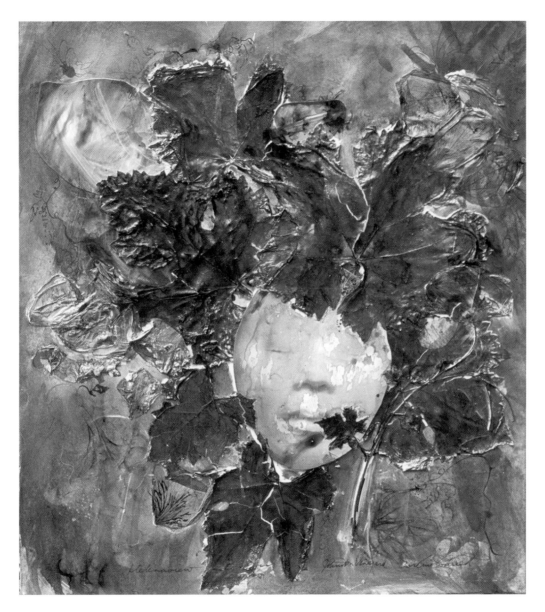

Caroline S. Garrett

Autumn Returns

mixed media collage, 16" x 16"

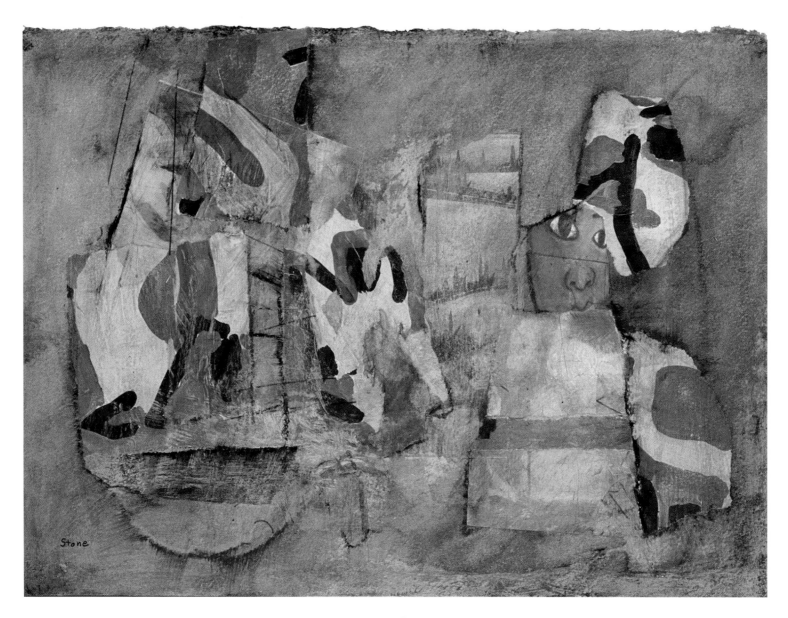

Mary Stone

New Eyes

mixed media collage, 11" x 15"

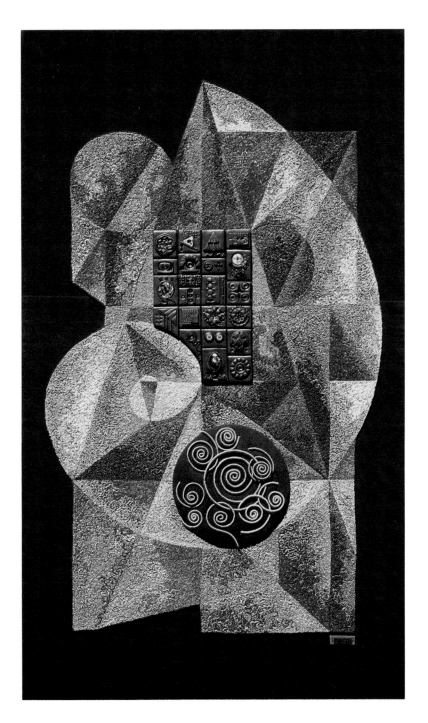

Wilcke H. Smith

Geometric Caprice

machine embroidery wrapping,
polymer clay, 39" x 27"

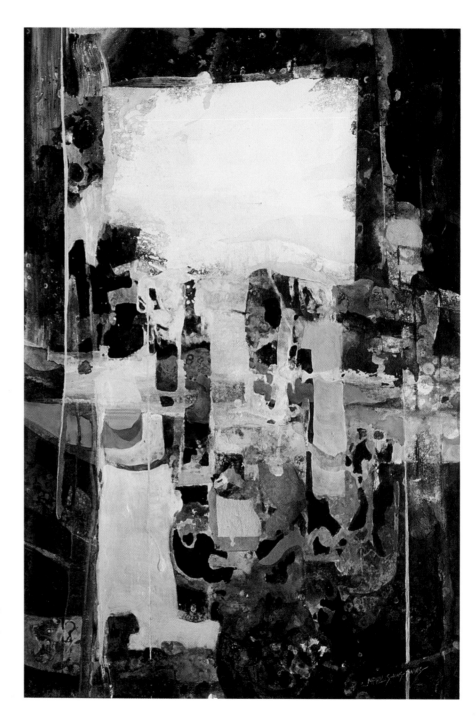

Marilyn Hughey Phillis

Geometric—9-11

watercolor, acrylic collage, 21.5" x 14.5"

160

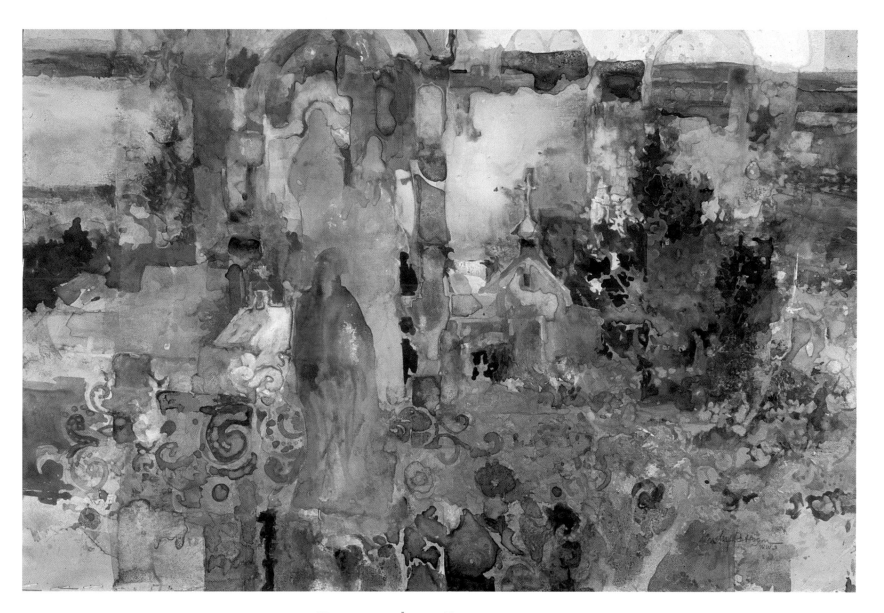

Dorothy Peterson

Llorona

watercolor, 14" x 21"

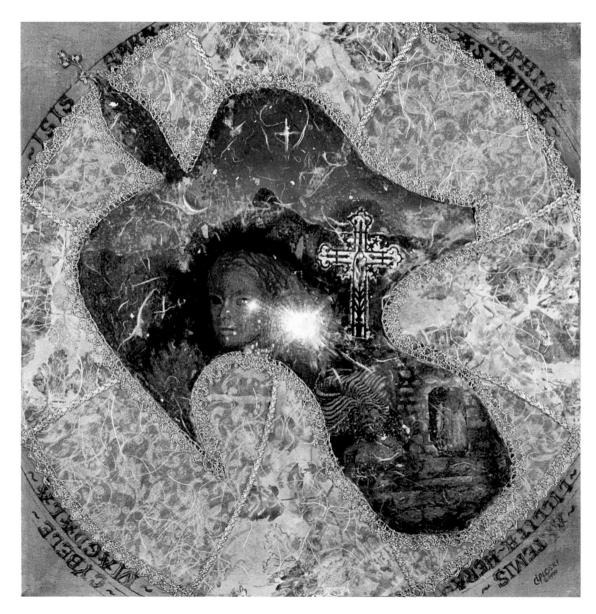

Cynthia Ploski

Birth of Wisdom, Sophia

mixed media, 19" x 19"

Ritchie Kaye

Womb Wisdom: Shulamith

mixed media fiber and beads, 15" x 15" x 2"

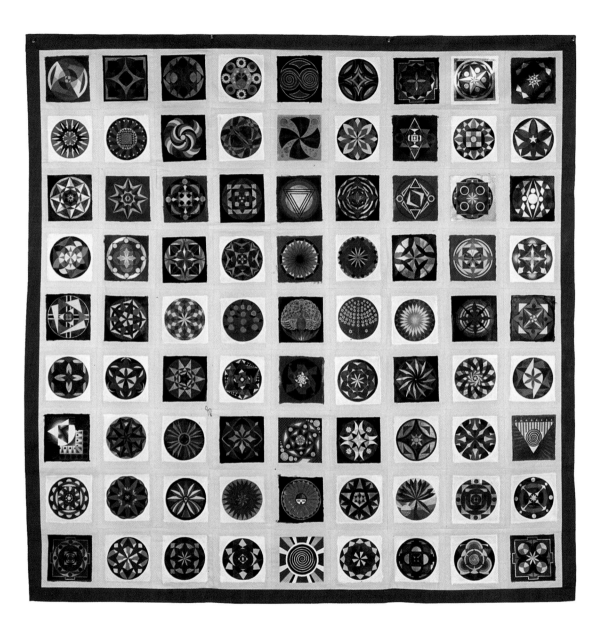

Nancy Marculewicz

Mantle of Healing

acrylic on unsized canvas, 80" x 80"

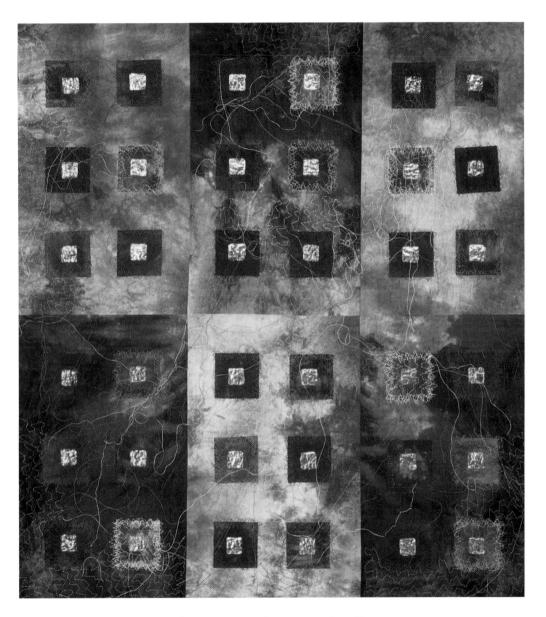

Renée Brainard Gentz

Exuberant

dyed cotton, gold foil, rayon, 37" x 34"

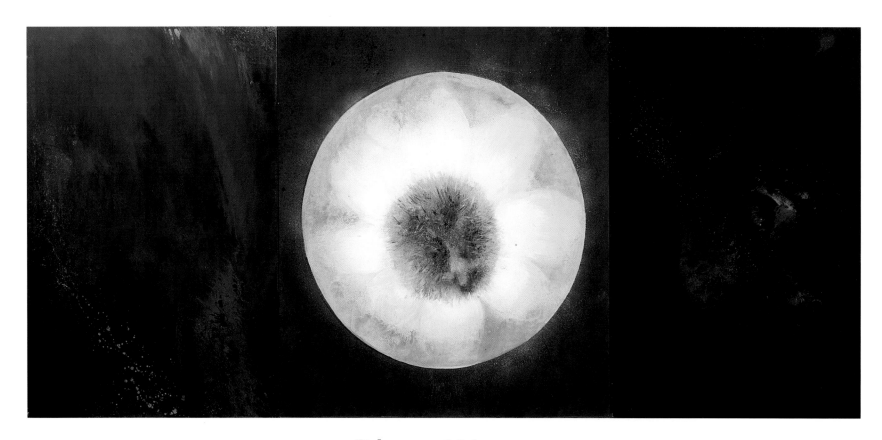

Diana Wong

Birth of Nu-Wah

acrylic, enamel, 72" x 160"

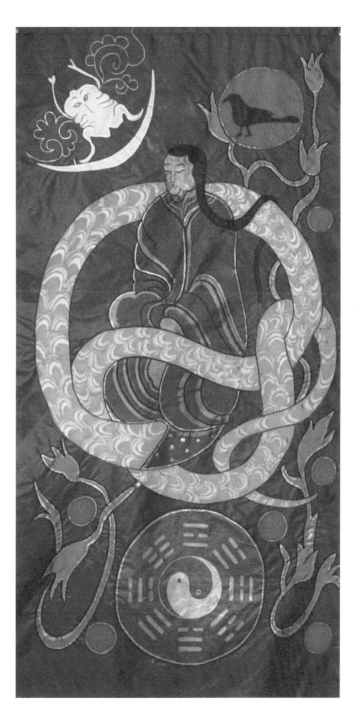

Lydia Ruyle

Nu Gua: Chinese Creatrix

collage, painted nylon banner, 72" x 36"

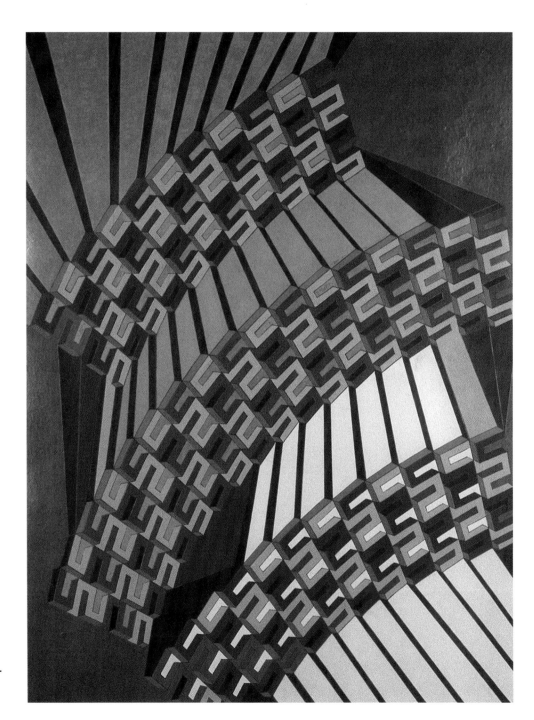

Rochelle Newman

Roller Coaster

acrylic on paper, 40" x 30"

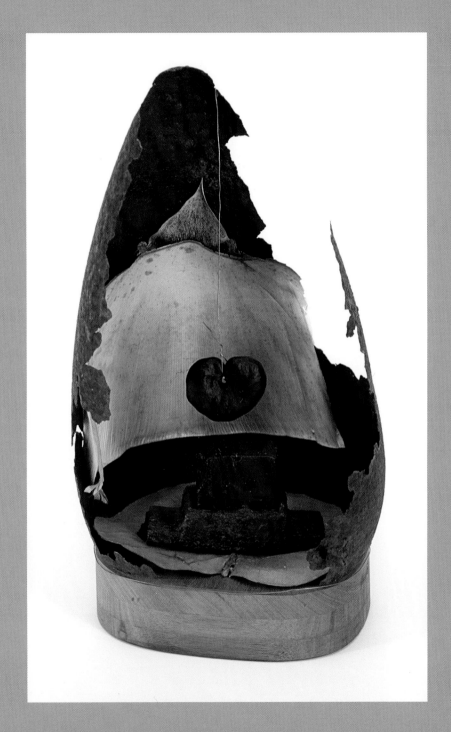

Kathy O'Meara

Regeneration Chamber

assemblage (rust, wood, natural objects),
14" x 5" x 5"

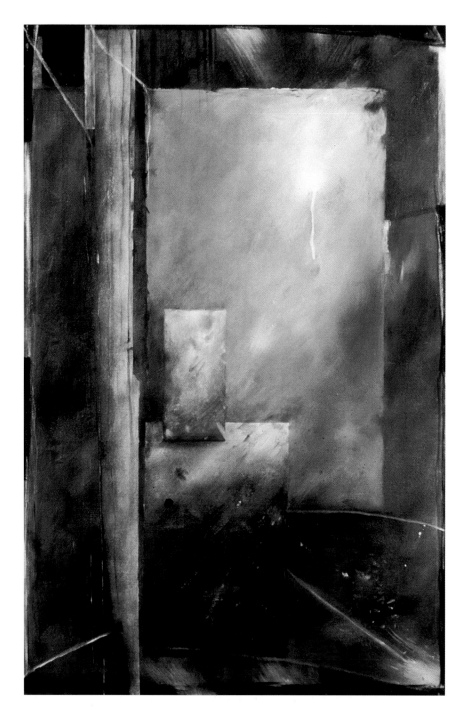

Bonnie Lorna Chapman

The Mind Settles in Solitude

acrylic on canvas, 36" x 24"

Jean Nevin

Night Passage
digital painting, 36" x 24"

Pam Walker Hart

Wrapped in Angel Thoughts

mixed media watermedia on paper, 11" x 11"

The Artists

KEY
F Full Member
F/H Full Member on Honorary Status
H Honorary Member
A Associate Member

The Society of Layerists in Multi-Media

The Society of Layerists in Multi-Media is a non-profit organization, founded in May 1982 in Albuquerque, NM to serve as a network for artists who express a holistic perspective.

There are two categories of membership: Associate, open to all interested persons, and Full, open to all artists whose work has been reviewed and accepted by the Membership Committee of three rotating members. Prospective members are encouraged to apply first as an Associate in order to become acquainted with the society. Full Member Applications are reviewed twice a year. Deadlines are December 31 and May 30.

To receive an application for membership, please contact:

slmm

P.O. Box 66480
Albuquerque, NM 87193
www.slmm.org